CUTE CHIBI ANIMALS

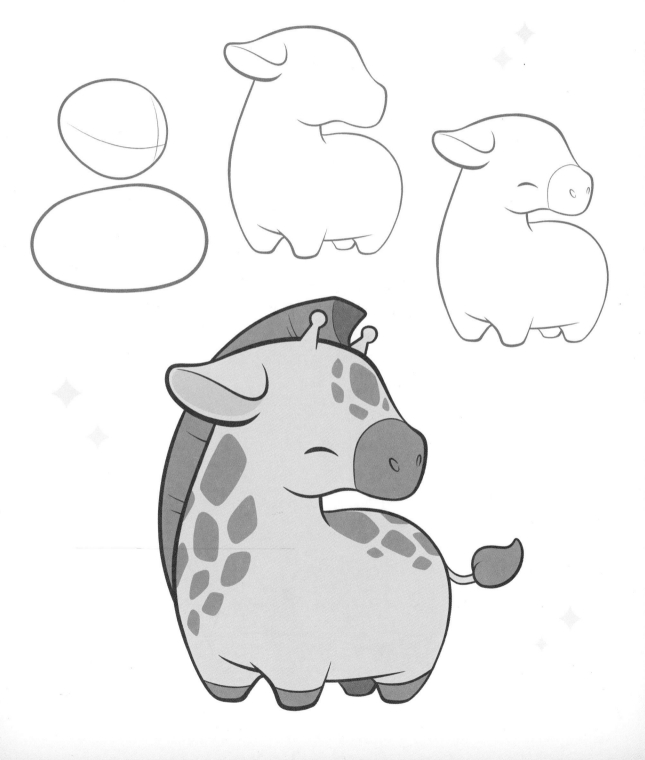

CUTE CHIBI ANIMALS
LEARN HOW TO DRAW
75 Cuddly Creatures

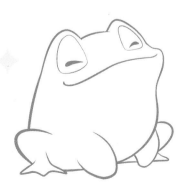

PHOEBE IM
CREATOR OF
BOBBLEJOT

ROCK
POINT

Text and Illustrations © 2021 by Phoebe Im

First published in 2021 by Rock Point, an imprint of The Quarto Group,
142 West 36th Street, 4th Floor, New York, NY 10018, USA
T (212) 779-4972 F (212) 779-6058 www.Quarto.com

Rock Point titles are also available at discount for retail, wholesale,
promotional and bulk purchase. For details, contact the Special Sales
Manager by email at specialsales@quarto.com or by mail at The Quarto
Group, Attn: Special Sales Manager, 100 Cummings Center Suite, 265D,
Beverly, MA 01915, USA.

Library of Congress Control Number: 2020944100

20 19 18 17 16

ISBN: 978-1-63106-729-7

Publisher: Rage Kindelsperger
Creative Director: Laura Drew
Managing Editor: Cara Donaldson
Senior Editor: Erin Canning
Cover & Interior Design: B. Middleworth

Printed in China

TO MY BELOVED HUSBAND,
WHO INSPIRES ME EVERY SINGLE DAY,
AND WITHOUT WHOM I WOULD NEVER
HAVE TAKEN THE LEAP TO PURSUE MY DREAMS
OF FULL-TIME ILLUSTRATION.

AND TO MY LOVING FAMILY,
WHO ENCOURAGED ME EVERY STEP OF THE WAY,
AND WITHOUT WHOM I WOULD NEVER HAVE TAKEN
THE FIRST STEP TO START DRAWING FOR FUN.

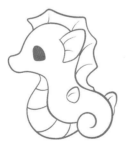

CONTENTS

HELLO!

My name is Phoebe, but I'm also known as Bobblejot. I started drawing at a very young age, but only settled into my current *kawaii* (Japanese for "cute") style of illustrating about two years ago. Last year, I created a webcomic about a corgi dog and a Munchkin cat called *Tori and Samuel*. Since then, I've been creating content for it and sharing it on social media platforms such as Instagram and Webtoon on a weekly basis.

 I was inspired to take the step toward creating a webcomic by a character I created and grew really fond of, and I hope that this book will be able to help you on your own road to creating your own set of adorable "chibi" characters and mascots!

WHAT IS CHIBI?

Chibis are most recognizable as mini versions of Japanese-style anime and manga "human" characters. They are defined by their large heads and tiny bodies, both of which contribute to their kawaii, or cuteness, factor. In anime shows and manga comics, chibis are often incorporated into more serious scenes as comic relief.

Over the years, chibis have become more diverse, with many different styles of drawing them (i.e., variations in details, anatomy, art style, etc.). Essentially, chibis are kind of like stylized caricatures of regular anime characters; certain facial and anatomical features are exaggerated while maintaining the overall identifying appearance of the character. Here are some key characteristics of chibis:

- A large head and small bodies and limbs.
- Faces with huge eyes and small noses and mouths.
- The hands and feet can be exaggerated to give a more "cartoonish" look.

To draw a chibi animal character, start by taking the key features of the animal and exaggerating them. For example, here's a full-size giraffe, with normal proportions, standing next to a chibi giraffe that has the same key features of a mane, two horns, a long neck and a nice, fluffy tail.

The idea is not only to give your chibi giraffe a larger head and chubbier limbs (which are common traits of chibi characters), but also to stylize the features that make a giraffe look like a giraffe, such as the mane, horns, and hooves.

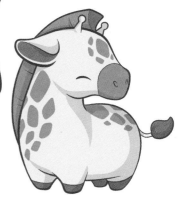

9

HOW TO USE THIS BOOK

After some helpful information here in the beginning of the book about Tools and Tips and Tricks for drawing, there are seventy-five step-by-step tutorials divided into four sections: Land Mammals; Aquatic & Semiaquatic Mammals; Birds; and Amphibians, Fish, Reptiles & More.

The animals within each section are arranged alphabetically, for the most part (there are a few out of order for layout purposes). Some tutorials are even accompanied by a Fun Fact, making this book not only an art book, but also a little educational. Let's get started!

TOOLS

For your own illustrations, feel free to use any medium you're comfortable with! For all the illustrations in this book, I used the MediBang Paint software for iPad Pro, but you can create the same illustrations with traditional tools like pencils, pens, markers, or anything else you may have handy.

TRADITIONAL TOOLS

If you're drawing your cute animals with traditional tools, draw all your steps with a pencil first and only go over your drawing with ink right before you're ready to color your artwork. The guidelines you will see throughout the step-by-step tutorials are meant to be erased once the inking is done, so be sure to do that before adding your colors! Also, you may want to invest in a high-quality eraser that will get rid of all those pencil lines.

1. Sketch and draw your character with a pencil.

2. Only use ink once you're happy with your final drawing. Erase any guidelines and then add color.

DIGITAL TOOLS

If you're drawing on your desktop or laptop, Adobe Photoshop, PaintTool SAI, and Clip Studio Paint are just some of the recommended software programs for artists. If you're like me and prefer using your iPad to create your illustrations, MediBang Paint and Procreate are just some of the tools that are intuitive and equipped with a wide variety of brushes and functions to help you create your artwork!

TIPS AND TRICKS

In this section, I share my tips and tricks for drawing, inking, coloring, shading, and highlighting chibi animals.

SKETCHING AND DRAWING To contribute to the cuddly and cuteness factor of your chibi animals, keep your shapes and lines nice and loose rather than sharp and angular. This means adding curves to your lines and rounding the points and corners of shapes like triangles and trapezoids.

FACIAL GUIDELINES When drawing a character's face, adding guidelines to show where the character is facing helps to position facial features, such as the eyes, nose, and mouth. As shown in the example below, the eyes should be centered on the horizontal guideline, the nose should be placed where the guidelines meet, and the mouth should be aligned with the vertical guideline.

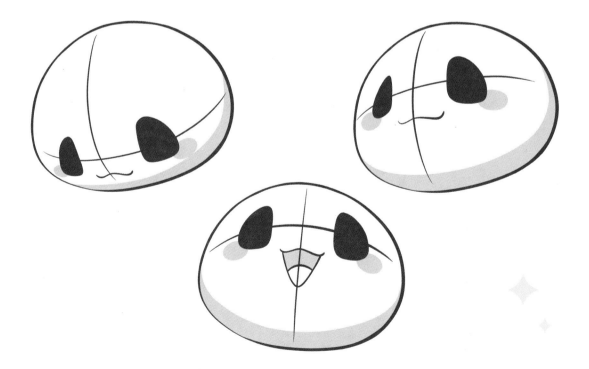

FACIAL EXPRESSIONS

Giving your character different facial expressions adds personality and makes them feel more relatable.

INKING LINES

When it is time to ink your character, drawing with consistently thin lines can make the final outline look a little flat.

Varying the thickness of your lines helps make the illustration feel more organic and interesting.

COLORING

In this book, you will learn how to draw chibi animals, but if you would like to color your characters, here's how you can add color to your drawing after you've inked your character.

1. Start with your inked animal.

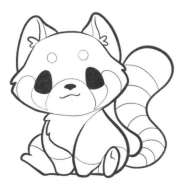

2. Add any distinctive markings to your character. Make sure to draw these markings in pencil, if you're drawing by hand, or on a separate sketch layer, if you're drawing digitally. You will erase/remove these lines when you're finished coloring in the markings.

3A. If you're coloring your artwork by hand, with colored pencils, Copic markers, or watercolors, fill in the sections with the different colors.

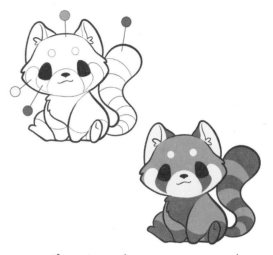

3B. If you're coloring your artwork digitally, fill in the overall outline with the character's most basic color. You can then add the colors for the markings layer by layer.

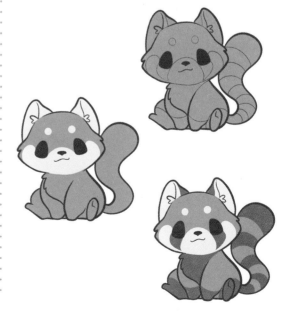

SHADING

Shadows depend on where the light is coming from. In the example below, the light source is coming from the top left. The colored spheres next to each character below show how the shadow is cast based on where this light source is positioned.

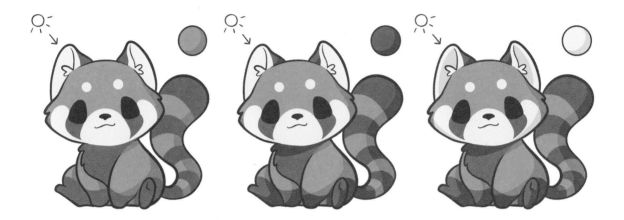

HIGHLIGHTING

For some characters with more reflective skins or textures, you'll want to add a little shine to the parts that are closest to the light source. As you can see with the example of the axolotl, the surfaces facing the light source are highlighted with a brighter color, while the shadows behave in the same way as in the Shading section above.

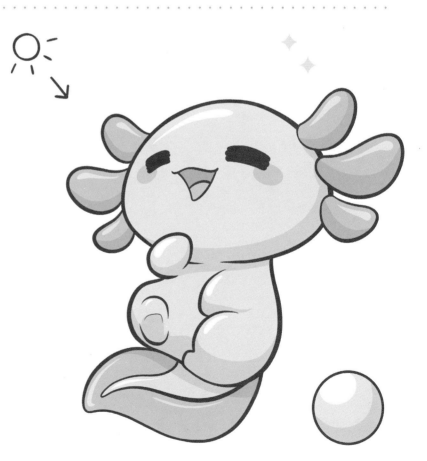

ACCESSORIZING

Once you're done drawing and coloring your characters, feel free to give them some cute clothes and accessories! Because of a chibi's small stature, the best rule is to keep these items somewhat simple. For example, you can add a detail like a huge button to a bag or a basic pattern on a T-shirt, as long as it doesn't make the item look too cluttered.

 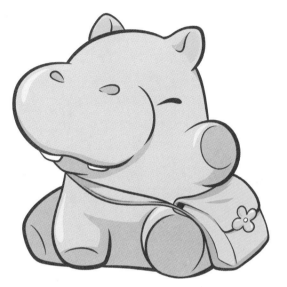

LAND MAMMALS

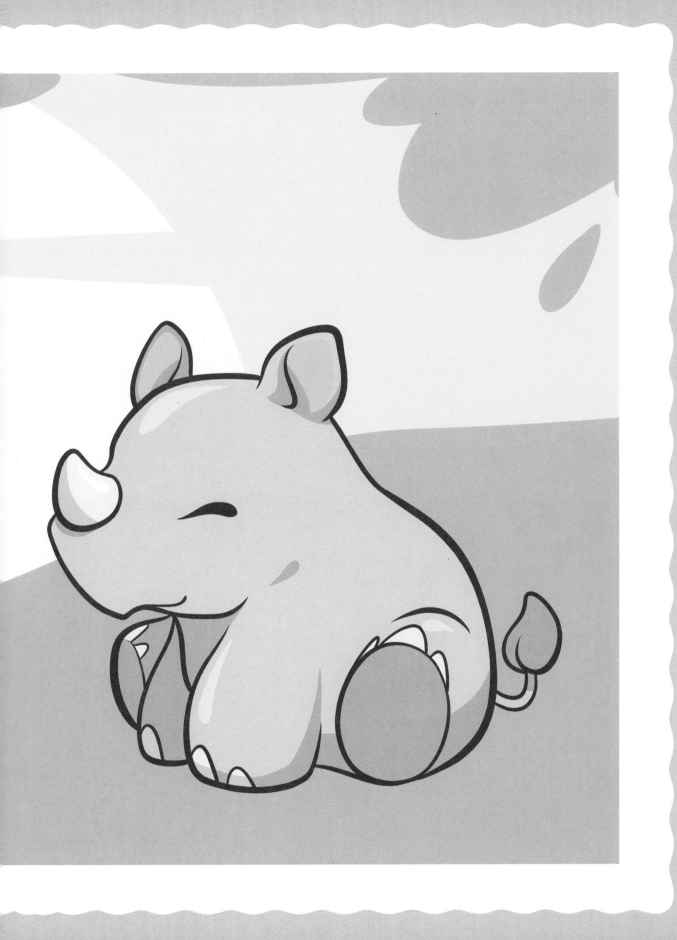

ALPACA

1.

Draw a circle for the head, with guidelines in the direction the alpaca is facing.

2.

Draw a large oval, overlapping the head, for the body.

3.

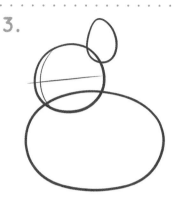

Add an egg-shaped oval on the right side of the head for the ear.

4.

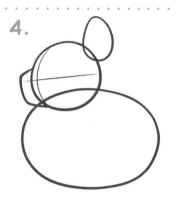

Add a snout to the face.

5.

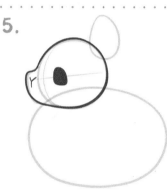

Refine the shape of the head. Place the eye and nose, making the eye an arch and the nose a Y shape.

6.

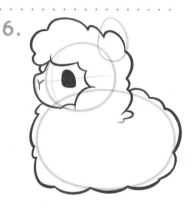

Give the alpaca its woolliness, following the shapes of the face, head, and body.

7.

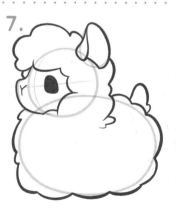

Draw the tail and ear as upside-down U shapes, adding a curved line inside the ear for its fold.

8.

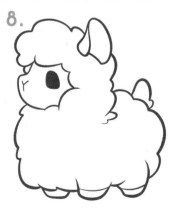

Finish your alpaca with three upside-down U shapes for the legs. Add lines to the legs for hooves.

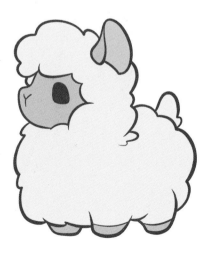

ANTEATER

1.

Draw a large egg shape for the body.

2.

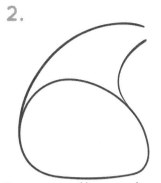

Draw two curved lines extending from the sides of the body for the head.

3.

Add a smaller oval inside the body for the haunch.

4.

Refine the shape of head, body, and leg using the lines as guides. Add some feet.

5.

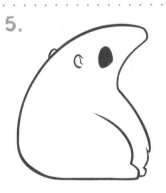

Add the eye as an arch and the ears as upside-down U shapes, with a curved line inside for the fold.

6.

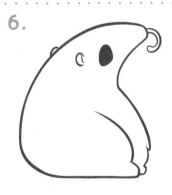

Draw a reverse, outlined C shape for the tongue.

7.

Draw the tail, adding fur with curved lines.

8.

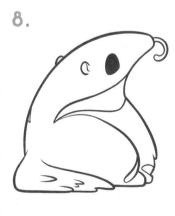

Finish your anteater with curved lines for its markings.

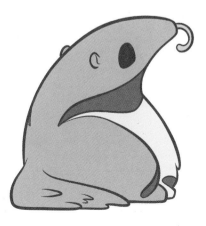

ARCTIC FOX

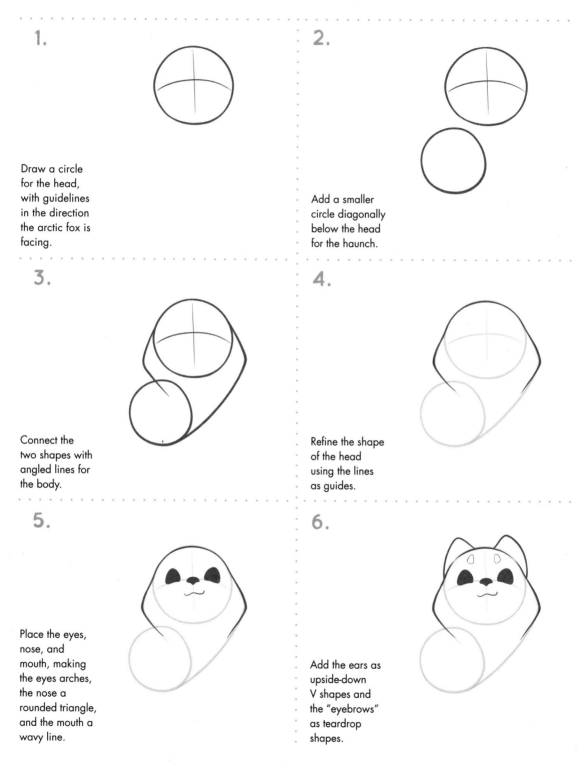

1.

Draw a circle for the head, with guidelines in the direction the arctic fox is facing.

2.

Add a smaller circle diagonally below the head for the haunch.

3.

Connect the two shapes with angled lines for the body.

4.

Refine the shape of the head using the lines as guides.

5.

Place the eyes, nose, and mouth, making the eyes arches, the nose a rounded triangle, and the mouth a wavy line.

6.

Add the ears as upside-down V shapes and the "eyebrows" as teardrop shapes.

FUN FACT: *Arctic foxes are the only land mammal native to Iceland, and also live in other parts of the Arctic tundra, including Canada, Russia, and Norway.*

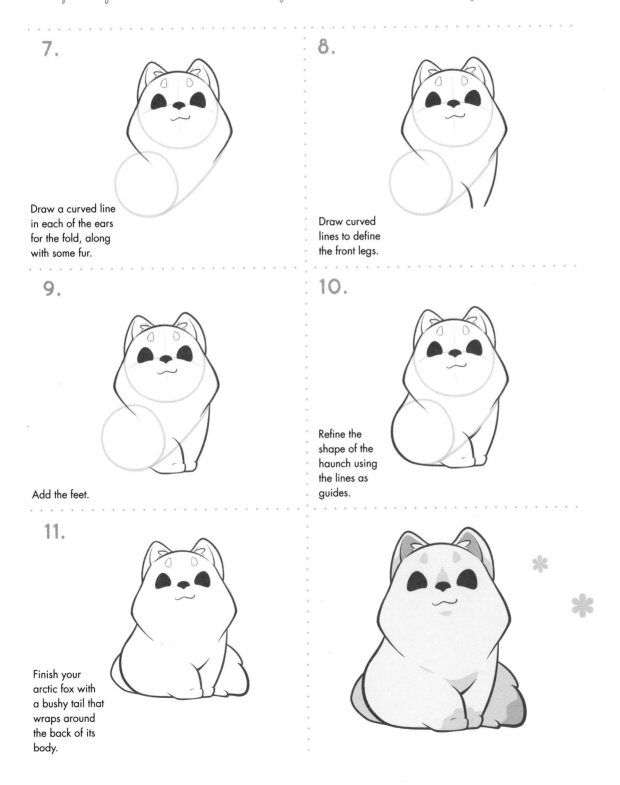

7.

Draw a curved line in each of the ears for the fold, along with some fur.

8.

Draw curved lines to define the front legs.

9.

Add the feet.

10.

Refine the shape of the haunch using the lines as guides.

11.

Finish your arctic fox with a bushy tail that wraps around the back of its body.

BAT

1.

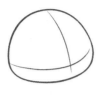

Draw a rounded trapezoid for the head, with guidelines in the direction the bat is facing.

2.

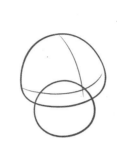

Add a small circle, overlapping the bottom left of the head, for the body.

3.

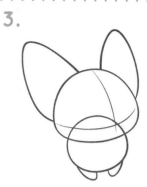

Draw two large, rounded, upside-down V shapes for the ears and two smaller, rounded V shapes for the feet.

4.

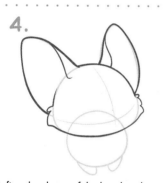

Refine the shape of the head and ears using the lines as guides. Add curved lines inside the ears for the folds and fur to the face.

5.

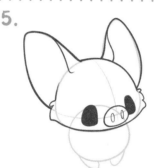

Place the eyes and nose following the facial guidelines. Make the eyes arches and the nose like a pig's snout.

6.

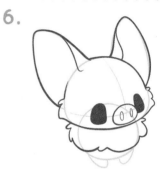

Add some fur below the head for the neck.

7.

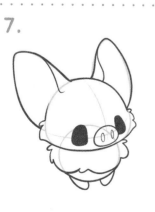

Refine the shape of the the body and feet using the lines as guides.

8.

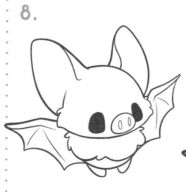

Finish your bat with the wings, adding three lines to each one for texture.

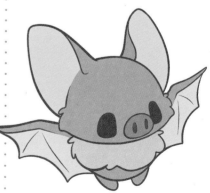

BEAR

1.

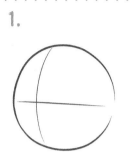

Draw a circle for the head, with guidelines in the direction the bear is facing.

2.

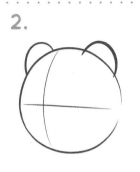

Add two upside-down U shapes for the ears.

3.

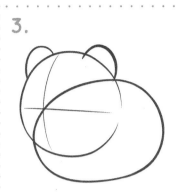

Draw a large oval, overlapping half of the head, for the body.

4.

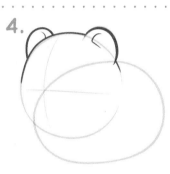

Refine the shape of the top of the head and the ears using the lines as guides. Add curved lines inside the ears for folds.

5.

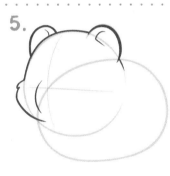

Add some fur to the left side of the head and a curved line to define the snout.

6.

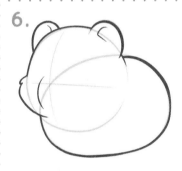

Refine the shape of the body using the lines as guides.

7.

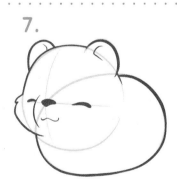

Place the eyes, nose, and mouth following the facial guidelines. Make the eyes elongated teardrops, the nose a rounded triangle, and the mouth a wavy line.

8.

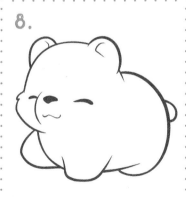

Finish your bear with two stout U shapes for the front legs, a curving line for the back leg, and a small U shape for the tail.

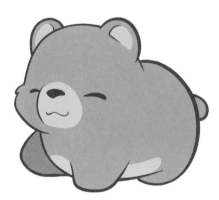

BOAR

1.

Draw a rounded trapezoid for the head/body, with guidelines in the direction the boar is facing.

2.

Draw a semicircle for the snout following the facial guidelines for placement.

3.

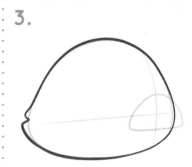

Refine the shape of the head/body using the lines for guides. Add a tuft of fur to the back of the body.

4.

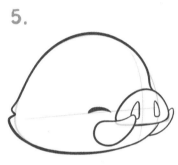

Refine the shape of the snout and add nostrils in the shape of tall triangles. Place the eye as an arch following the facial guidelines.

5.

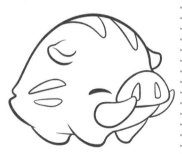

Add two tusks, with the front one as a rounded triangle and the back one as an upside-down V shape.

6.

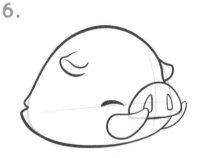

Draw U shapes for the ears, with a curved line inside the front one for the fold.

7.

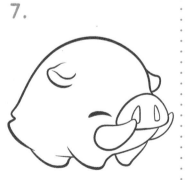

Add three stout U shapes for the legs.

8.

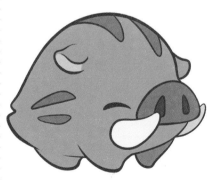

Finish your boar with patterns for its markings.

CHINCHILLA

1.

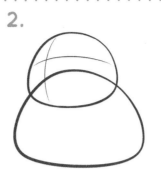

Draw a rounded trapezoid for the head, with guidelines in the direction the chinchilla is facing.

2.

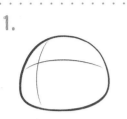

Draw a larger, rounded trapezoid, overlapping the head, for the body.

3.

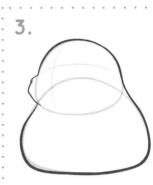

Refine the shape of the head and body using the lines as guides. Add some fur to the left side of the head.

4.

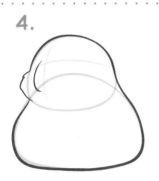

Draw a curved line on the face to define the snout.

5.

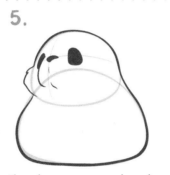

Place the eyes, nose, and mouth. Make the eyes arches, the nose a rounded triangle, and the mouth two short, curved lines.

6.

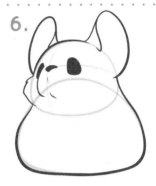

Add two large, upside-down U shapes as ears, with curved lines inside for the folds.

7.

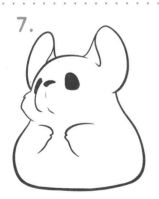

Draw two short arms as U shapes, giving them some furry texture.

8.

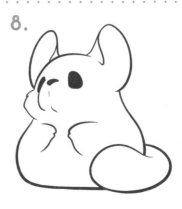

Finish your chinchilla with a thick tail that wraps around from the back of the body to the front.

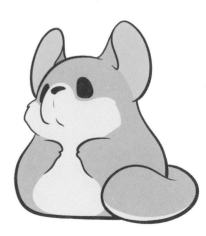

CAT

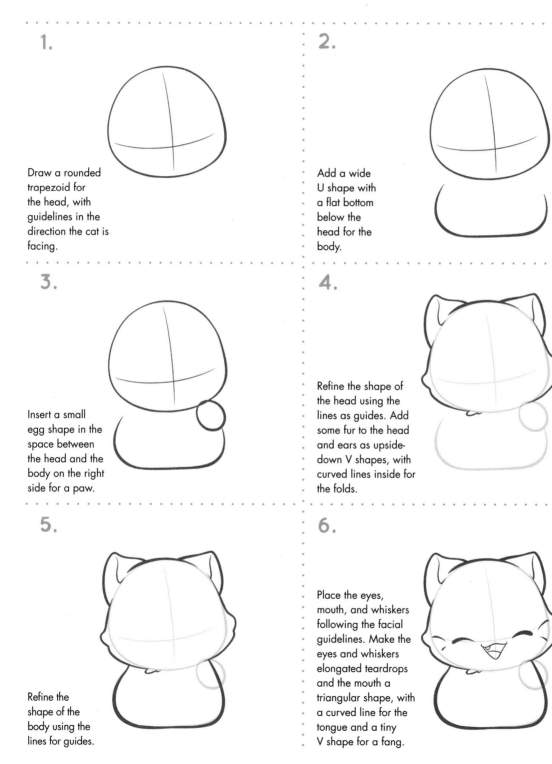

1.

Draw a rounded trapezoid for the head, with guidelines in the direction the cat is facing.

2.

Add a wide U shape with a flat bottom below the head for the body.

3.

Insert a small egg shape in the space between the head and the body on the right side for a paw.

4.

Refine the shape of the head using the lines as guides. Add some fur to the head and ears as upside-down V shapes, with curved lines inside for the folds.

5.

Refine the shape of the body using the lines for guides.

6.

Place the eyes, mouth, and whiskers following the facial guidelines. Make the eyes and whiskers elongated teardrops and the mouth a triangular shape, with a curved line for the tongue and a tiny V shape for a fang.

FUN FACT: *The only other animals that walk with the same gait as cats are giraffes and camels.*

7.

Refine the shape of the paw. Add some short, curved lines for the pads on the bottom. Draw the leg on the left side as a wide U shape.

8.

Finish your cat with the tail as an outlined C shape that is wider at the top.

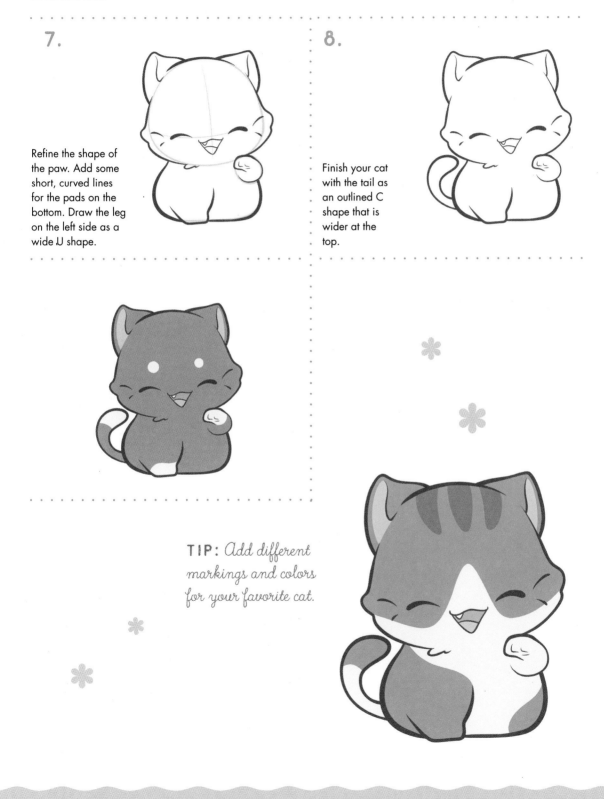

TIP: *Add different markings and colors for your favorite cat.*

COW

1.

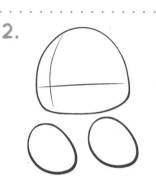

Draw a rounded trapezoid for the head, with guidelines in the direction the cow is facing.

2.

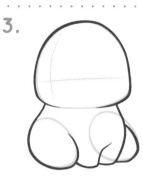

Draw two small ovals below the head for the haunches.

3.

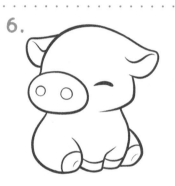

Outline the head and haunches using the lines as guides. Connect them with curved lines for the body and define the front and back legs.

4.

Place the muzzle as an oval following the facial guidelines.

5.

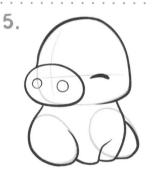

Place the eye as an elongated teardrop. Add two small circles to the muzzle for nostrils.

6.

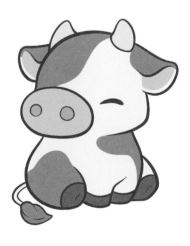

Draw floppy ears as U shapes, with curved lines inside for the folds. Add lines to the legs for hooves.

7.

Draw horns, with the one on the right side as a rounded triangle and the one on the left side as an upside-down V shape.

8.

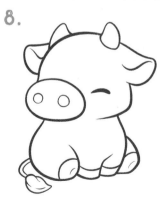

Finish your cow with a skinny tail that has a tuft of fur on the end.

DEER

1.

Draw a circle for the head, with a guideline in the direction the deer is facing.

2.

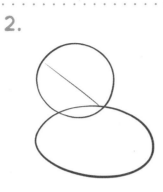

Draw a large oval, slightly overlapping the head, for the body.

3.

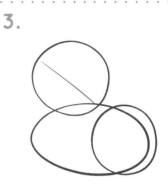

Draw a smaller oval, with the majority of it overlapping the right side of the body, for the haunch.

4.

Refine the shape of the head and torso using the lines as guides. Add the snout to the head.

5.

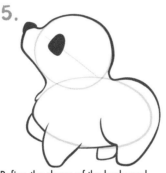

Refine the shape of the body and haunch. Add four U-shaped legs. Place the eye and nose, making the eye an arch and the nose a triangle.

6.

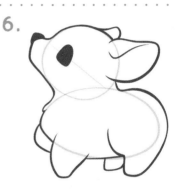

Add the ears as V shapes, with a curved line inside for the fold.

7.

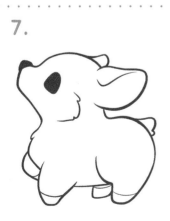

Draw some fur on the head, along with a tuft of fur for the tail.

8.

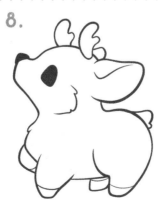

Finish your deer with some impressive antlers.

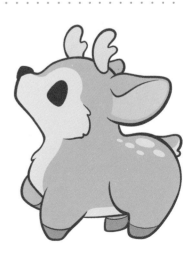

DOG

1.

Draw a circle for the head, with guidelines in the direction the dog is facing.

2.

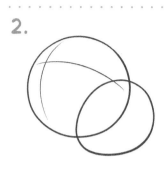

Draw a small oval, overlapping the head, for the body.

3.

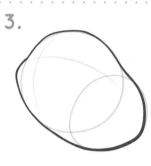

Refine the shape of the head and body using the lines as guides.

4.

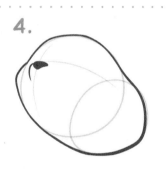

Place the nose and define the snout following the facial guidelines. Make the nose a rounded triangle and the snout a curved line.

5.

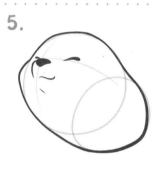

Place the eyes and mouth. Make the eyes elongated teardrops and the mouth a wavy line. Add a dash of a line for the chin.

6.

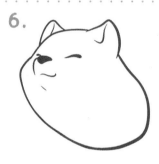

Add ears as upside-down V shapes, with curved lines inside for the folds.

7.

Draw two front legs as U shapes.

8.

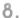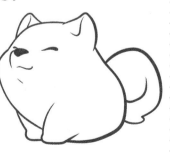

Finish your dog with a large, fluffy tail.

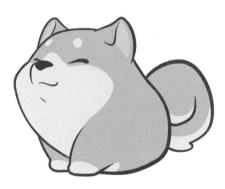

ELEPHANT

1.
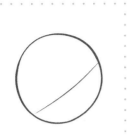

Draw a circle for the head, with a guideline in the direction the elephant is facing.

2.
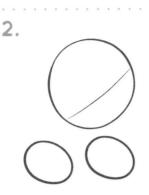

Add two small ovals below the head for the legs.

3.
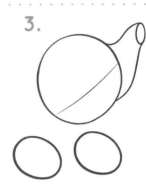

Draw a smaller oval above the head and connect it with curved lines to the head for the trunk.

4.

Refine the shape of the head, trunk, and body using the lines as guides. Add a large, floppy ear as a U shape.

5.
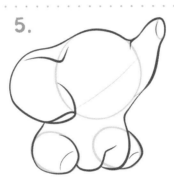

Add details to the trunk, ears, and legs with curved lines.

6.
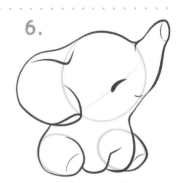

Place the eye and mouth following the facial guidelines. Make the eye an elongated teardrop and the mouth a curved line.

7.
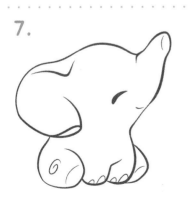

Add two toenails to each of the front feet as upside-down U shapes. Draw a swirl on the leg on the right side for a knee.

8.
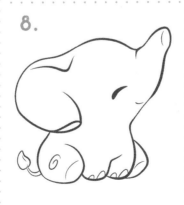

Finish your elephant with a thin tail that has a tuft of fur on the end.

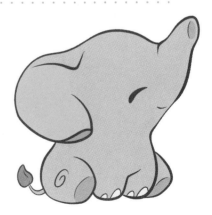

FERRET

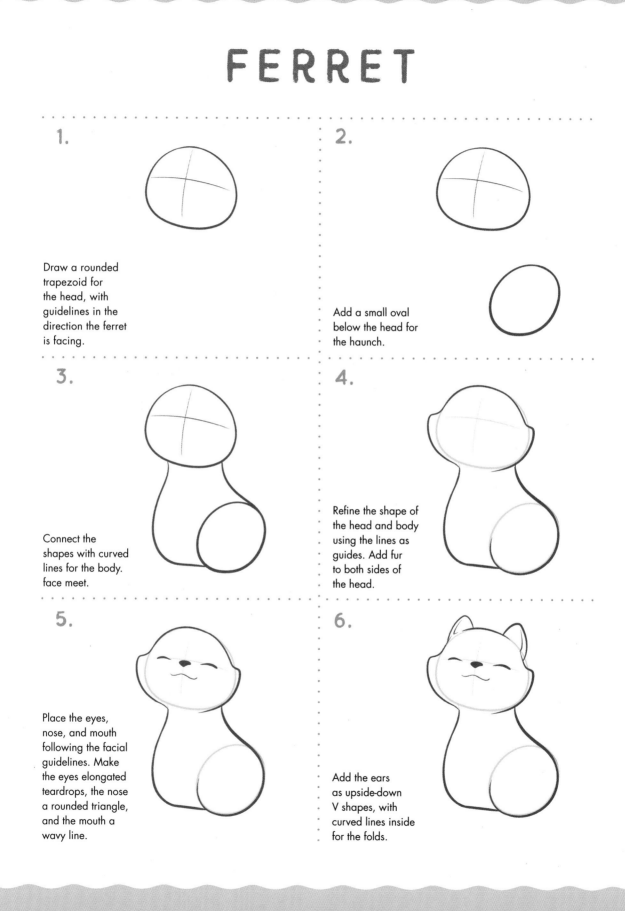

1.

Draw a rounded trapezoid for the head, with guidelines in the direction the ferret is facing.

2.

Add a small oval below the head for the haunch.

3.

Connect the shapes with curved lines for the body. face meet.

4.

Refine the shape of the head and body using the lines as guides. Add fur to both sides of the head.

5.

Place the eyes, nose, and mouth following the facial guidelines. Make the eyes elongated teardrops, the nose a rounded triangle, and the mouth a wavy line.

6.

Add the ears as upside-down V shapes, with curved lines inside for the folds.

Ferrets were domesticated over two thousand years ago and became popular as pets in modern times in the 1980s and '90s.

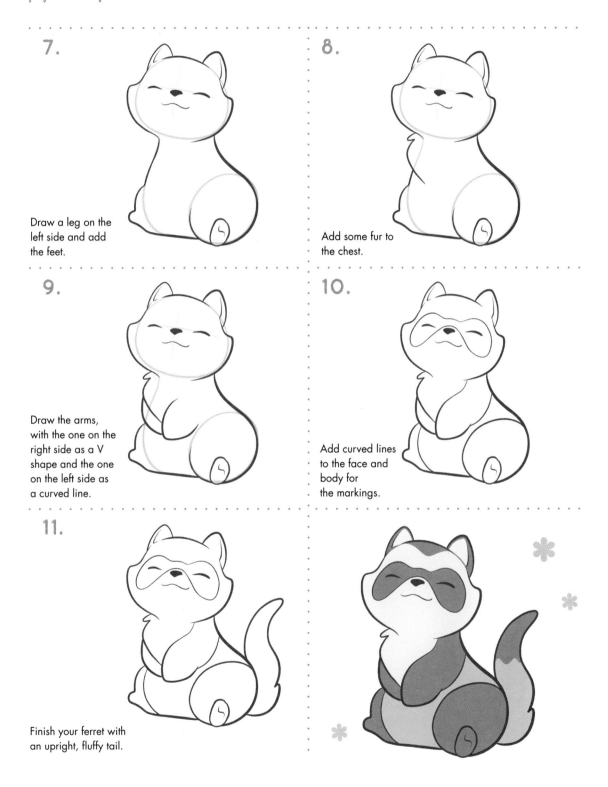

7.

Draw a leg on the left side and add the feet.

8.

Add some fur to the chest.

9.

Draw the arms, with the one on the right side as a V shape and the one on the left side as a curved line.

10.

Add curved lines to the face and body for the markings.

11.

Finish your ferret with an upright, fluffy tail.

FOX

1.

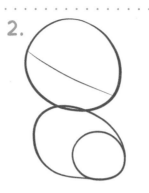

Draw an oval for the head, with a guideline in the direction the fox is facing.

2.

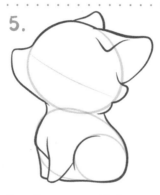

Add a slightly smaller oval below the head for the body, with a smaller one inside of it for the haunch.

3.

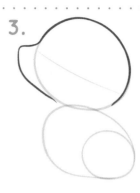

Refine the shape of the head using the lines as guides. Add a snout.

4.

Refine the shape of the body and haunch, adding the front legs.

5.

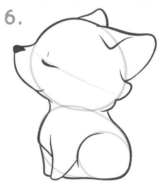

Draw the ears as upside-down V shapes, with a curved line inside for the fold. Add some fur to the head.

6.

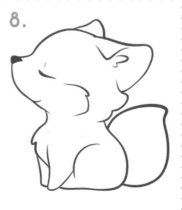

Place the facial features, making the eye an elongated teardrop, the nose a triangle, and the mouth a curved line. Add a tiny curve above the eye.

7.

Add more fur to the face, chest, and ear.

8.

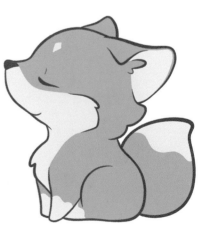

Finish your fox with a fluffy tail.

GIANT PANDA

1.

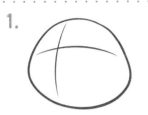

Draw a rounded trapezoid for the head, with guidelines in the direction the giant panda is facing.

2.

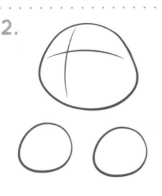

Draw two small ovals below the head for the back legs.

3.

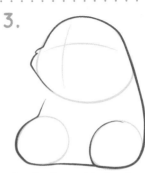

Refine the shape of the head and legs. Connect the shapes with curved lines for the body. Add some fur to the left side of the head.

4.

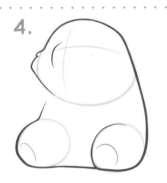

Draw a curve on the head to define the snout. Add curved lines to the legs for the feet.

5.

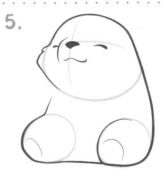

Place the eyes, nose, and mouth, making the eyes elongated teardrops, the nose a rounded triangle, and the mouth a wavy line.

6.

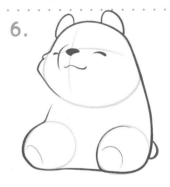

Add the ears as upside-down U shapes and the tail as a small semicircle.

7.

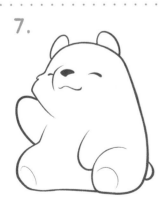

Draw the front legs as U shapes.

8.

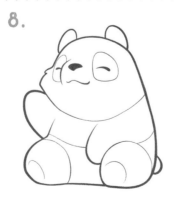

Finish your giant panda with patterns and lines on the face, chest, and legs for its markings.

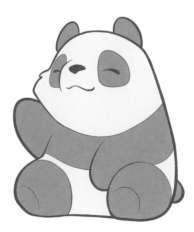

GIRAFFE

1.

Draw an oval for the head, with guidelines in the direction the giraffe is facing.

2.

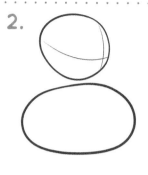

Draw a larger oval below the head for the body.

3.

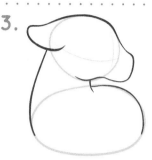

Refine the shape of the head and part of the body. Connect the shapes with curved lines for the neck, and add a floppy ear to the left side of the head and a snout to the right side.

4.

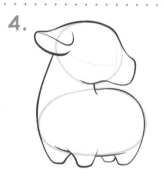

Refine the remaining part of the body. Add four short legs as U shapes and a curved line inside the ear for the fold.

5.

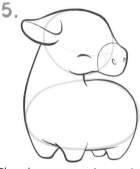

Place the eye as an elongated teardrop. Define the snout with a curved line and add tiny ovals for nostrils.

6.

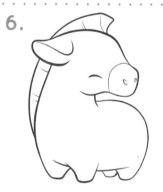

Draw the mane from the top of the head to halfway down the body. Add some thin lines to give it texture.

7.

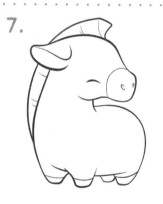

Add lines to the legs for hooves.

8.

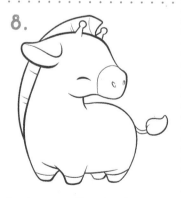

Finish your giraffe with a short, thin tail that has a tuft of fur on the end and a pair of distinctive horns on top of the head.

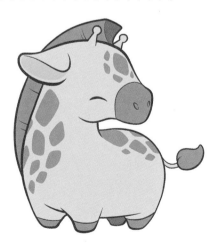

GOAT

1.

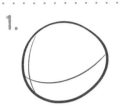

Draw an oval for the head, with guidelines in the direction the goat is facing.

2.

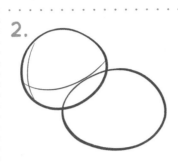

Draw a larger oval, slightly overlapping the head, for the body.

3.

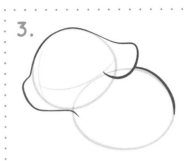

Refine the shape of the head and the back using the lines as guides. Add a floppy ear to the right side of the head and a muzzle to the left side.

4.

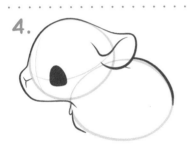

Place the eye and nose following the facial guidelines. Make the eye an arch and the nose a Y shape. Add a curved line to the ear for the fold. Give the chest some fur.

5.

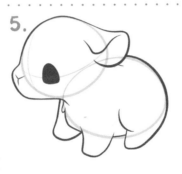

Outline the remaining body using the lines as guides. Draw three legs as U shapes and define the back haunch with a curved line.

6.

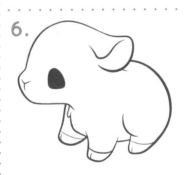

Add some lines to the legs for cloven hooves.

7.

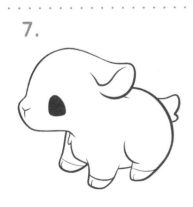

Draw a short, fluffy tail.

8.

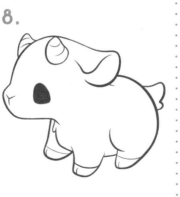

Finish your goat with some horns, adding lines to them for texture.

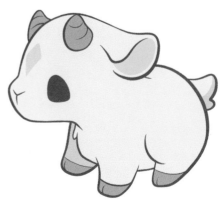

HAMSTER

1.

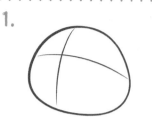

Draw a rounded trapezoid for the head, with guidelines in the direction the hamster is facing.

2.

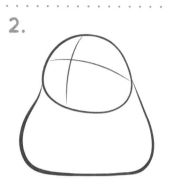

Draw a large, curving U shape, with a flat base, below the head for the body.

3.

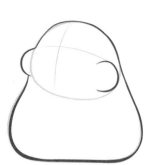

Refine the shape of the head and the body using the lines as guides. Add cheek pouches protruding from the sides of the head.

4.

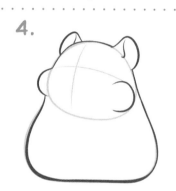

Draw the ears as upside-down U shapes, with curved lines inside for the folds.

5.

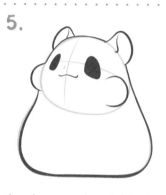

Place the eyes and mouth following the facial guidelines. Make the eyes arches and the mouth a wavy line.

6.

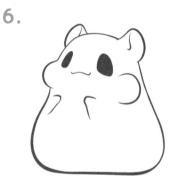

Add front paws by drawing hooked lines.

7.

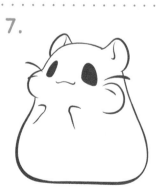

Draw two whiskers on each cheek as elongated teardrops.

8.

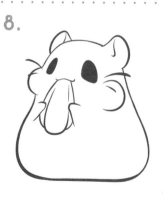

Finish your hamster by adding a sunflower seed for it to hold and chew on.

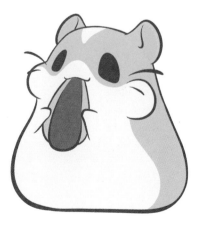

HEDGEHOG

1.

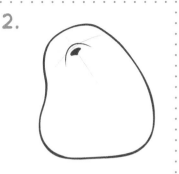

Draw a large jelly-bean shape for the head/body that tilts to the left, with guidelines in the direction the hedgehog is facing.

2.

Place the snout and nose following the facial guides. Make the snout an arched line and the nose a rounded triangle.

3.

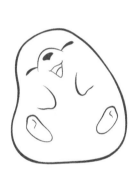

Place the eyes and mouth. Make the eyes elongated teardrops and the mouth a triangular shape, with a curved line for the tongue.

4.

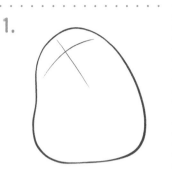

Draw U shapes for the front arms.

5.

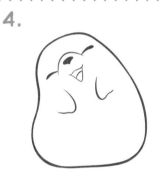

Add oblong ovals for the feet. Give them some texture with curved lines.

6.

Start the spines at the center of the forehead.

7.

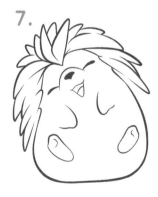

Add more spines, moving out to the right and left sides of the head.

8.

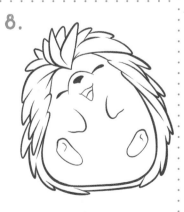

Finish your hedgehog with even more spines down the sides and around the base of the body.

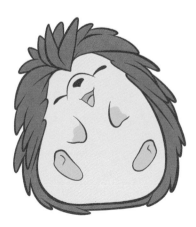

HORSE

1.

Draw an oval for the head, with guidelines in the direction the horse is facing.

2.

Add a smaller oval, overlapping the head, for the snout.

3.

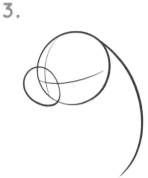

Draw a large curve off the back of the head for the neck and side of the body.

4.

Draw a large oval below the head, overlapping it, for the rest of the body.

5.

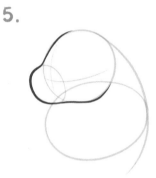

Refine the shape of the front of the head and the snout using the lines as guides.

6.

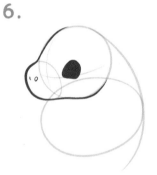

Place the eye as an arch following the facial guidelines and draw tiny ovals for the nostrils.

7.

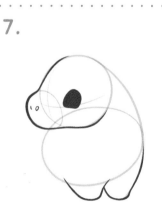

Add two stout U shapes for the front legs.

8.

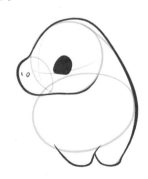

Refine the shape of the back of the head, the neck, and the side of the body using the lines as guides.

9.

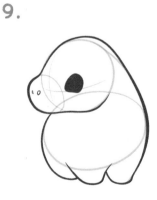

Refine the shape of the rest of the body. Add the back leg.

10.

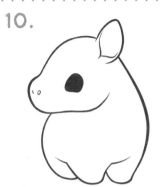

Draw the ear as an upside-down V shape, with two curved lines inside for the folds.

11.

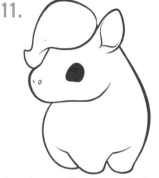

Start drawing the mane on the front and top of the head, swooping it to the side.

12.

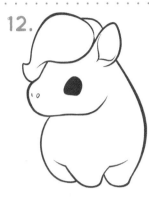

Draw more of the mane off the ear and behind the swoopy section.

13.

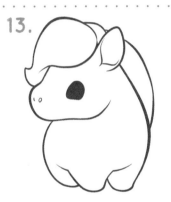

Draw a long, curved line along the neck for the rest of the mane.

14.

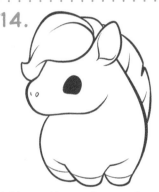

Add curved lines to the mane for texture, along with lines to the legs for hooves.

15.

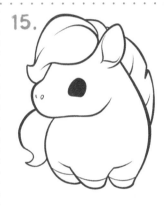

Draw a long, thick tail.

16.

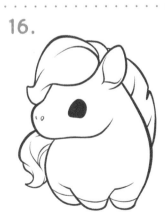

Finish your horse by adding curved lines throughout its tail for texture.

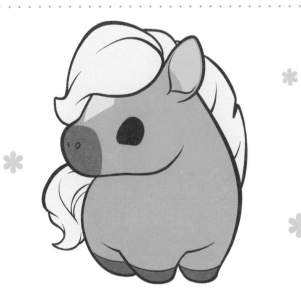

KANGAROO

1.

Draw an oval for the head, with a guideline in the direction the kangaroo is facing.

2.

Add three slightly smaller ovals below the head for the body and legs.

3.

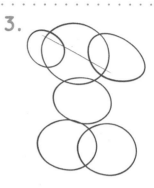

Add two ovals, with the right one larger than the left one, overlapping the head, for the ear and nose.

4.

Draw two semiovals below the legs for the feet.

5.

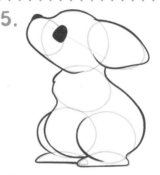

Refine the shape of the kangaroo. Add some fur to the chest. Place the eye and nose, making the eye an arch and the nose a rounded triangle.

6.

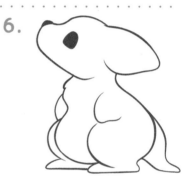

Add the arm on the right side as a U shape and the one on the left as a curved line. Draw a pointy, curved tail.

7.

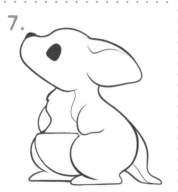

Draw a horizontal line across the front of the body to define the pouch.

8.

Finish your kangaroo by adding a baby to its pouch. Repeat the steps above for a smaller version of the head and add small ovals for the arms.

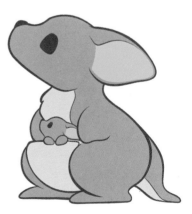

KOALA

1.

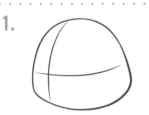

Draw a rounded trapezoid for the head, with guidelines in the direction the koala is facing.

2.

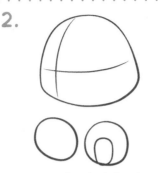

Draw two small circles below the head for the legs. Add a small oval shape inside the right circle for the foot.

3.

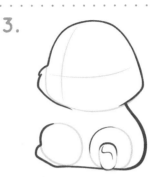

Refine the shape of the head, legs, and foot. Add fur to the left side of the head. Connect the head to the legs with a curved line for the body.

4.

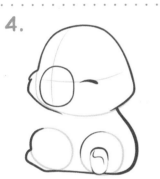

Place the eye and nose following the facial guidelines. Make the eye an elongated teardrop and the nose a bulbous oval.

5.

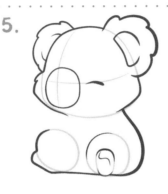

Draw furry semicircles for the ears, with smaller semicircles inside to define their shape.

6.

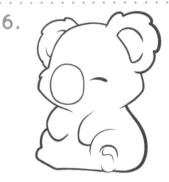

Add some U shapes for the arms.

7.

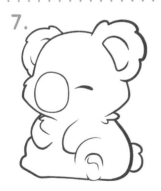

Add more fur to the neck and chest, along with a short, fluffy tail.

8.

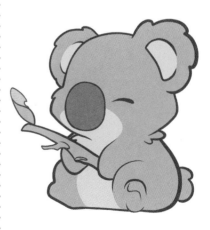

If you want, finish your koala by having it hold a tree branch!

LION

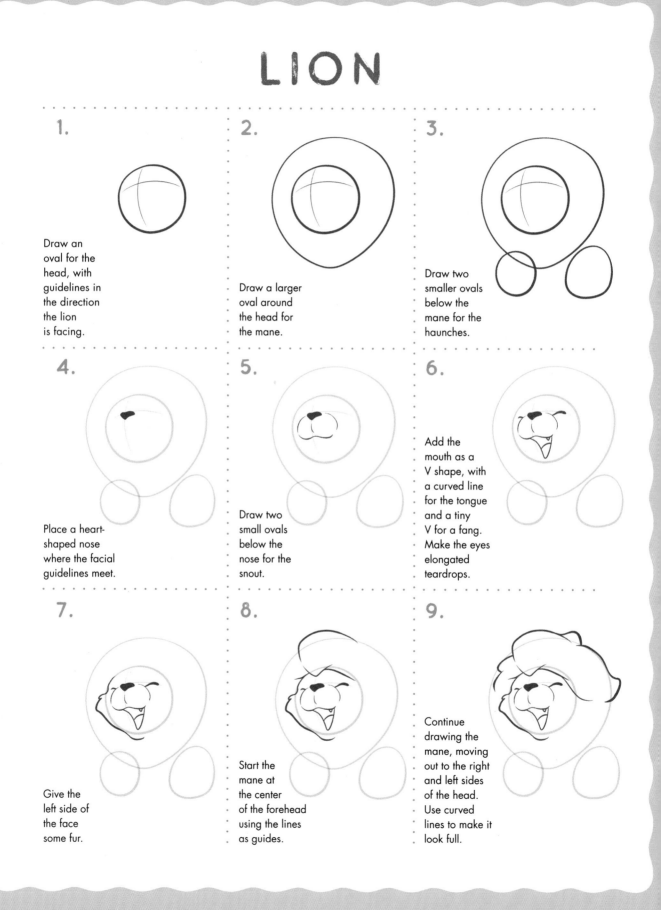

1.
Draw an oval for the head, with guidelines in the direction the lion is facing.

2.
Draw a larger oval around the head for the mane.

3.
Draw two smaller ovals below the mane for the haunches.

4.
Place a heart-shaped nose where the facial guidelines meet.

5.
Draw two small ovals below the nose for the snout.

6.
Add the mouth as a V shape, with a curved line for the tongue and a tiny V for a fang. Make the eyes elongated teardrops.

7.
Give the left side of the face some fur.

8.
Start the mane at the center of the forehead using the lines as guides.

9.
Continue drawing the mane, moving out to the right and left sides of the head. Use curved lines to make it look full.

FUN FACT: *Lions may be known as the "kings of the jungle," but they are second in size to tigers, and they don't live in the jungle.*

10.

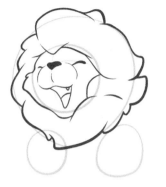

Complete the mane around the lower half of the head.

11.

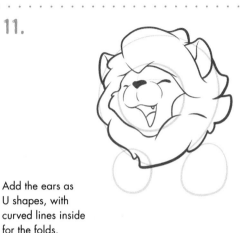

Add the ears as U shapes, with curved lines inside for the folds.

12.

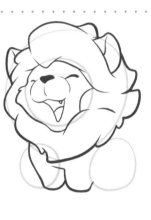

Draw the front legs as upside-down U shapes between the haunches.

13.

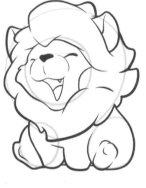

Refine the shape of the haunches, connecting the one on the right side to the mane with a curved line. Add some feet too.

14.

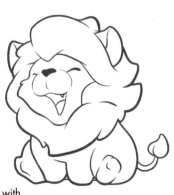

Finish your lion with a thin tail that has a tuft of fur on the end.

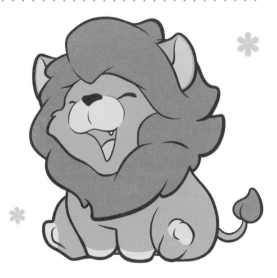

MONKEY

1.

Draw a rounded trapezoid for the head, with guidelines in the direction the monkey is facing.

2.

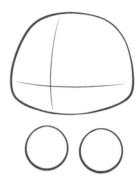

Add two small circles below the head for the legs.

3.

Refine the shape of the head and legs using the lines as guides. Connect them with curved lines for the body and add feet.

4.

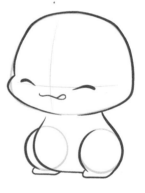

Place the eyes and mouth following the facial guidelines. Make the eyes elongated teardrops and the mouth a wavy line with a loop off the right side for the tongue.

5.

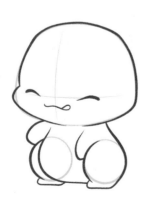

Add arms as U shapes.

6.

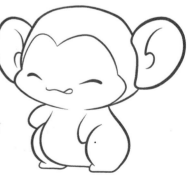

Draw large, round ears, with curved lines inside for the folds. Add curved lines to the face for markings.

7.

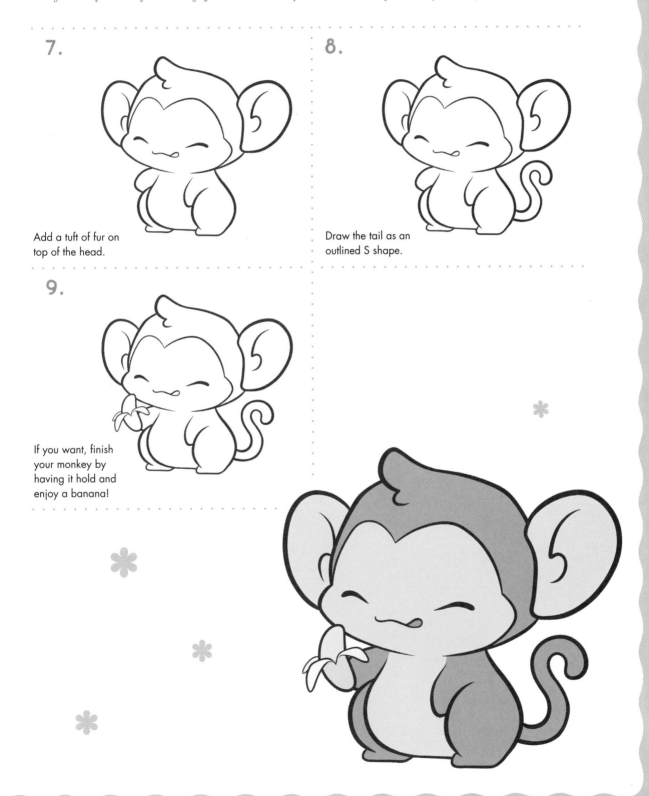

Add a tuft of fur on top of the head.

8.

Draw the tail as an outlined S shape.

9.

If you want, finish your monkey by having it hold and enjoy a banana!

MOUSE

1.

Draw an oval for the head, with guidelines in the direction the mouse is facing.

2.

Draw a larger oval below the head for the body.

3.

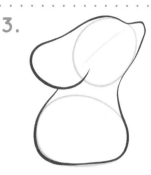

Refine the shape of the head and body using the lines as guides. Add a large ear off the left side of the head and a snout off the right side.

4.

Place the eye, nose, and mouth, making the eye an arch, the nose a rounded triangle, and the mouth an elongated teardrop shape, with a line inside for the tongue. Add a curved line to the ear.

5.

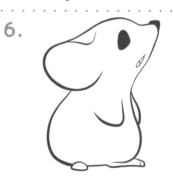

Add feet to the base of the body.

6.

Draw the front arm as a U shape and the back one as a curved line.

7.

Add a tuft of fur on top of the head.

8.

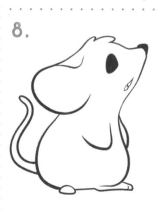

Finish your mouse with a long, curved tail.

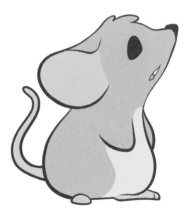

PIG

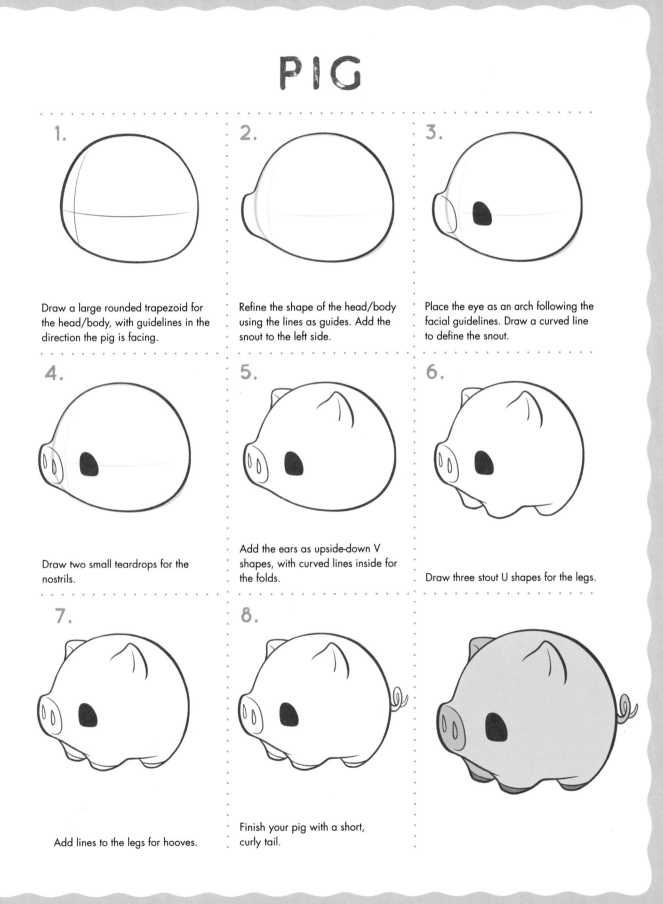

1. Draw a large rounded trapezoid for the head/body, with guidelines in the direction the pig is facing.

2. Refine the shape of the head/body using the lines as guides. Add the snout to the left side.

3. Place the eye as an arch following the facial guidelines. Draw a curved line to define the snout.

4. Draw two small teardrops for the nostrils.

5. Add the ears as upside-down V shapes, with curved lines inside for the folds.

6. Draw three stout U shapes for the legs.

7. Add lines to the legs for hooves.

8. Finish your pig with a short, curly tail.

PANGOLIN

1.

Draw an oval for the head, with a guideline in the direction the pangolin is facing.

2.

Draw a small circle below the head for the haunch.

3.

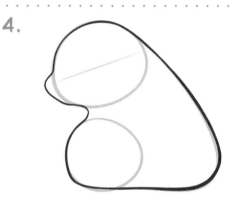

Draw a large curve that connects the head to the haunch for the body.

4.

Refine the shape of the head, body, and haunch using the lines as guides. Add a snout to the left side of the head.

5.

Place the eye as an arch following the facial guideline. Draw the ear as an upside-down U shape, with a curved line inside for the fold.

6.

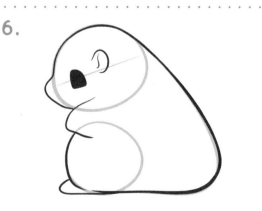

Draw the front leg as a U shape. Add a foot to the back leg.

The pangolin's scales are made of keratin, the same protein as human hair and nails, and they make up 20 percent of its total body weight.

7.

Add a short, curved tail off the back of the body.

8.

Draw curved lines around the eyes for the markings on the face.

9.

Add scales along the head, back, and front leg.

10.

Finish your pangolin by adding more scales all over its body.

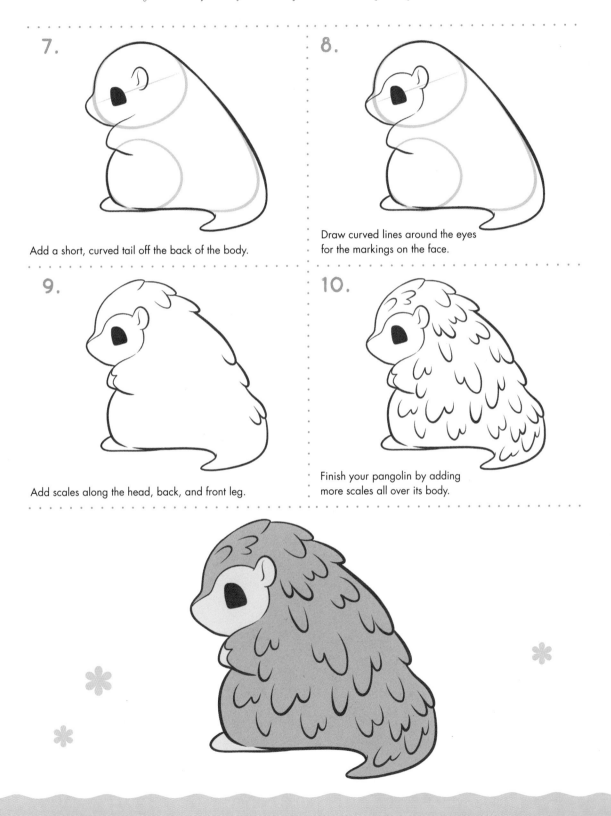

RABBIT

1.

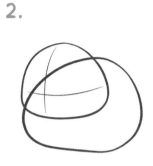

Draw a rounded trapezoid for the head, with guidelines in the direction the rabbit is facing.

2.

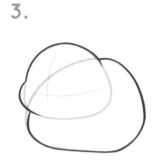

Draw a large oval, overlapping half of the head, for the body.

3.

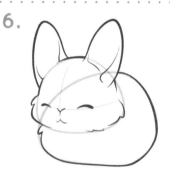

Refine the shape of the head and body using the lines as guides.

4.

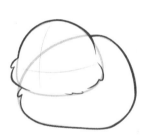

Add fur to the sides of the head and to the chest.

5.

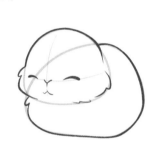

Place the facial features, making the eyes elongated teardrops, the nose a Y shape, and the mouth a wavy line.

6.

Draw two long ears as upside-down V shapes, with curved lines inside for the folds.

7.

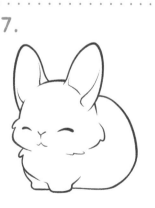

Add short front legs as flat U shapes.

8.

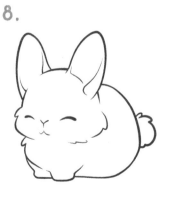

Finish your rabbit with a furry ball for the tail.

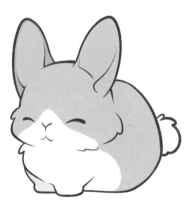

REINDEER

1.

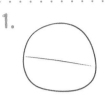

Draw a circle for the head, with guidelines in the direction the reindeer is facing.

2.

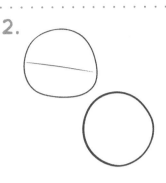

Draw another circle diagonally below the head for the haunch.

3.

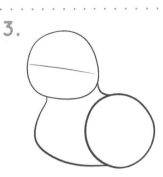

Connect the shapes with curved lines for the body.

4.

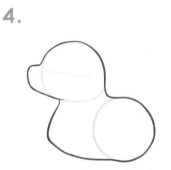

Refine the shape of the head, body, and haunch using the lines as guides. Add the snout to the left side of the head.

5.

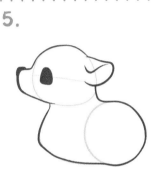

Place the eye and nose, making the eye an arch and the nose a triangle. Draw the ear, with a curved line for the fold.

6.

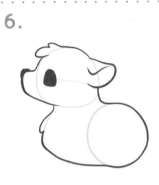

Add some fur to the forehead and chest.

7.

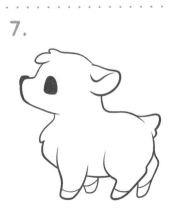

Draw the four legs as U shapes. Add lines to the legs for hooves.

8.

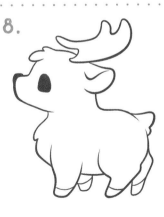

Finish your reindeer with impressive antlers.

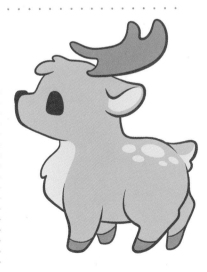

RACCOON

1.

Draw a rounded trapezoid for the head, with guidelines in the direction the raccoon is facing.

2.

Draw two small circles below the head for the haunches.

3.

Refine the shape of the head using the lines as guides. Add fur to the sides of the head.

4.

Place the eyes, nose, and mouth following the facial guidelines. Make the eyes arches, the nose a rounded triangle, and the mouth a wavy line.

5.

Draw large ears as upside-down V shapes, with the outer lines extending longer than the inner lines. Add curved lines inside for the folds, along with some tufts of fur.

6.

Refine the shape of the haunches, adding feet. Connect the head to the haunches with a curved line for the body.

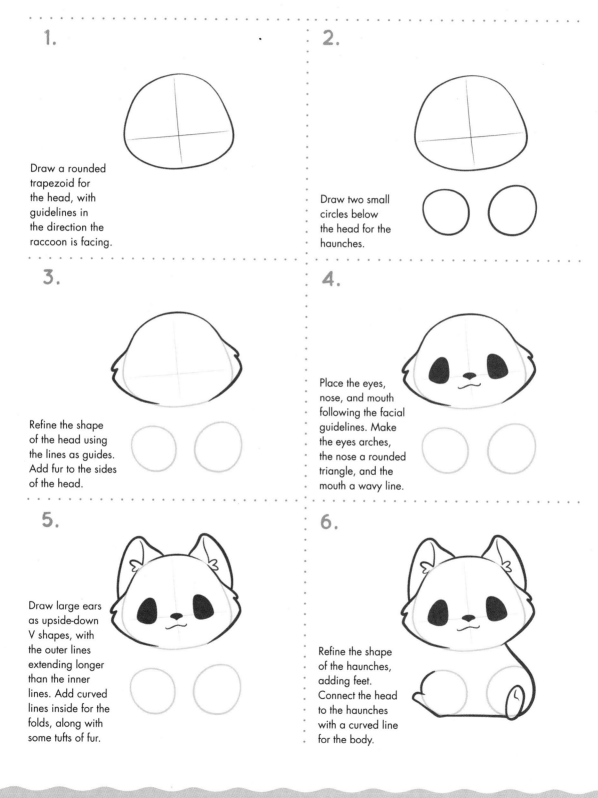

FUN FACT: Raccoons are deemed intelligent animals by scientists, and city raccoons have been found to be more clever than rural ones.

7.

Add some fur to the chest.

8.

Draw the front legs as U shapes.

9.

Finish your raccoon with a big, bushy tail.

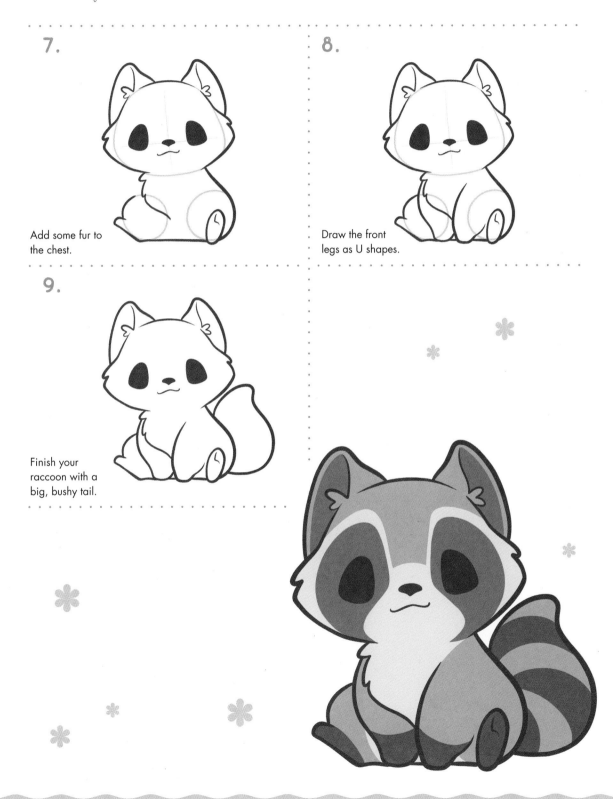

RAM

1.

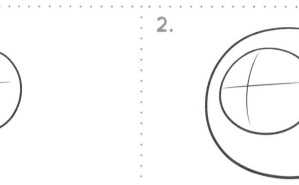

Draw an oval for the head, with guidelines in the direction the ram is facing.

2.

Draw a larger oval around the head for the body.

3.

Draw two smaller ovals, overlapping the top of the body, for the horns.

4.

Refine the shape of the body using the lines as guides. Make this shape quite woolly.

5.

Place the eyes and nose following the facial guidelines. Make the eyes arches and the nose a Y shape.

6.

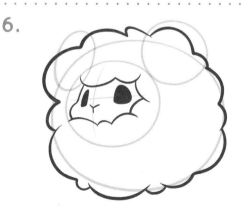

Refine the shape of the head, giving it lots of woolliness.

FUN FACT: Also known as male bighorn sheep, rams can have horns that weigh up to 30 pounds (14 kg), and when fighting for dominance, two rams can charge at each other at 20 miles per hour (32 km).

7.

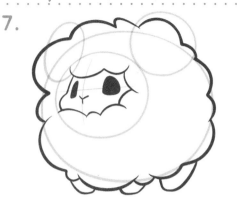

Draw the three legs as short U shapes.

8.

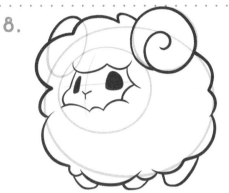

Refine the shape of the horns, drawing the front horn as a round swirl and the back horn as a curved line.

9.

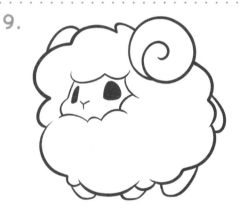

Finish your ram with a tail that is a simple curved line.

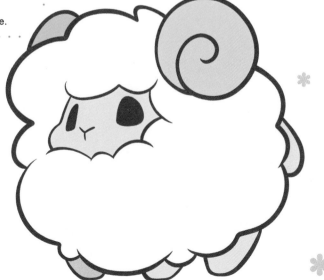

RED PANDA

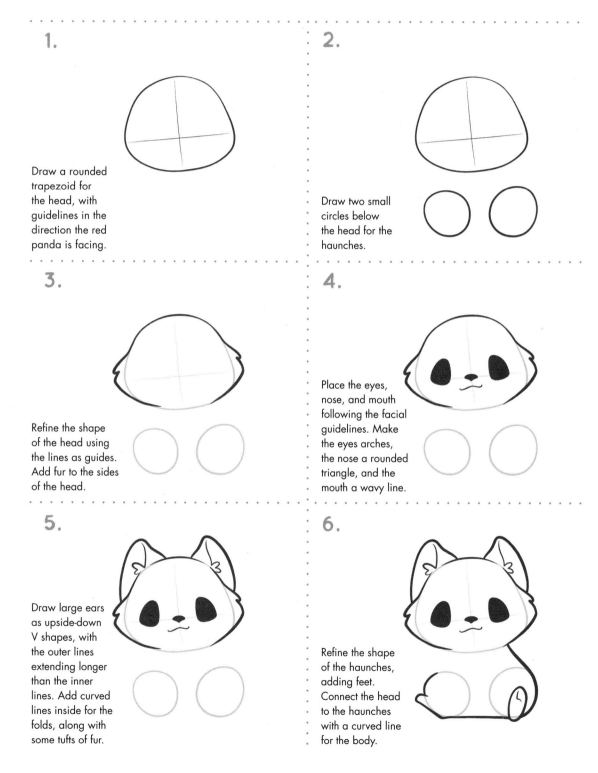

1.

Draw a rounded trapezoid for the head, with guidelines in the direction the red panda is facing.

2.

Draw two small circles below the head for the haunches.

3.

Refine the shape of the head using the lines as guides. Add fur to the sides of the head.

4.

Place the eyes, nose, and mouth following the facial guidelines. Make the eyes arches, the nose a rounded triangle, and the mouth a wavy line.

5.

Draw large ears as upside-down V shapes, with the outer lines extending longer than the inner lines. Add curved lines inside for the folds, along with some tufts of fur.

6.

Refine the shape of the haunches, adding feet. Connect the head to the haunches with a curved line for the body.

FUN FACT: The red panda is not much bigger than a house cat, but its 18-inch-long (45 cm) tail gives it some extra length and helps keep it warm when wrapped around its body.

7.

Add some fur to the chest.

8.

Draw the front legs as U shapes.

9.

Finish your red panda with a long, thick, curved tail.

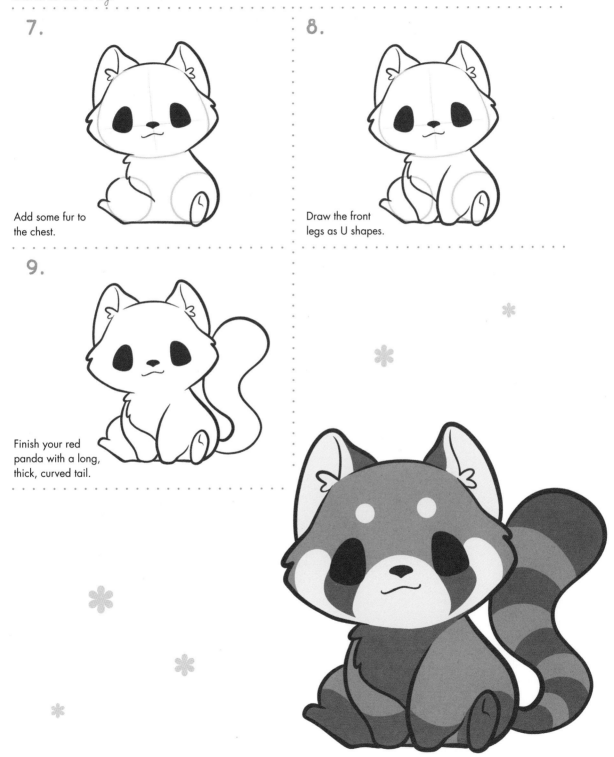

RHINOCEROS

1.

Draw a circle for the head, with a guideline in the direction the rhinoceros is facing.

2.

Draw a large rounded trapezoid, overlapping the head, for the body.

3.

Refine the shape of the head and body using the lines as guides. Add the protruding snout to the left side of the head.

4.

Draw the ears as upside-down V shapes, with curved lines inside for the folds.

5.

Place the eye and mouth following the facial guidelines. Make the eye an elongated teardrop and the mouth a curved line.

6.

Draw the horn on the snout as a rounded triangle. Curve the baseline of the triangle to give the horn depth.

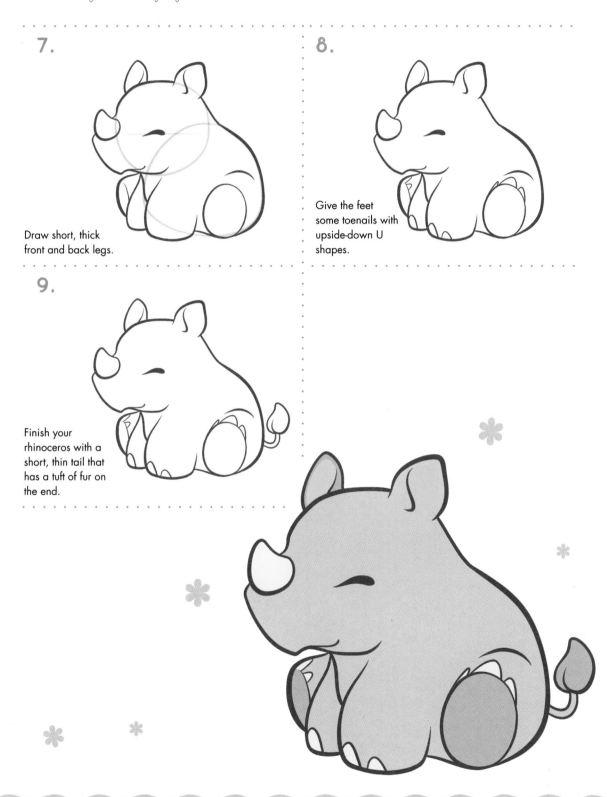

7.

Draw short, thick front and back legs.

8.

Give the feet some toenails with upside-down U shapes.

9.

Finish your rhinoceros with a short, thin tail that has a tuft of fur on the end.

SKUNK

1.

Draw a circle for the head, with a guideline in the direction the skunk is facing.

2.

Draw a similarly sized rounded trapezoid below the head for the haunch.

3.

Connect the two shapes with curved lines for the body.

4.

Refine the shape of the skunk using the lines as guides. Add a snout to the left side of the head and a leg to the haunch.

5.

Place the eye, nose, and mouth, making the eye an elongated teardrop, the nose a rounded triangle, and the mouth a curved line. Place a tiny, curved line above the eye.

6.

Add the ear as an upside-down U shape, with a curved line inside for the fold.

FUN FACT: Not everyone can smell a skunk. About one in one thousand (lucky) people don't have the ability to discern its scent.

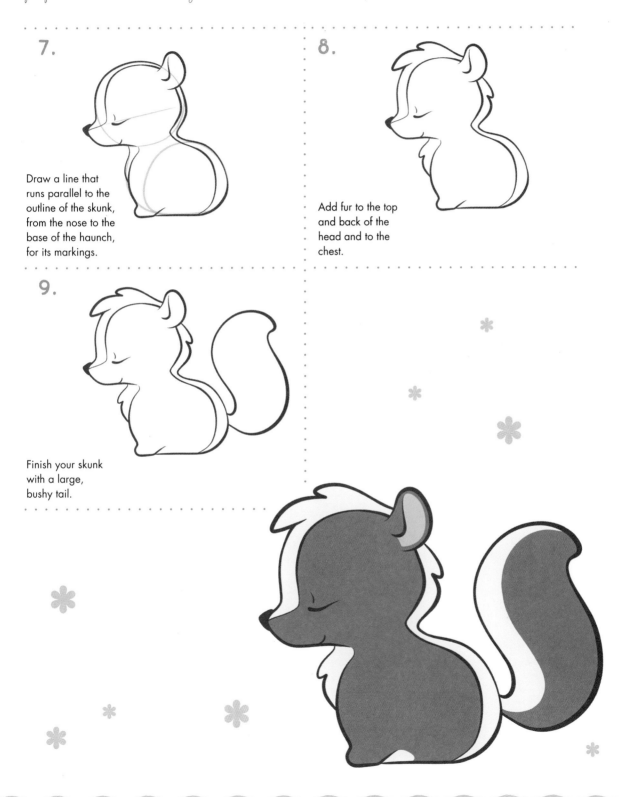

7.

Draw a line that runs parallel to the outline of the skunk, from the nose to the base of the haunch, for its markings.

8.

Add fur to the top and back of the head and to the chest.

9.

Finish your skunk with a large, bushy tail.

SLOTH

1.

Draw a large, slightly rounded trapezoid for the head/body and two small ovals, overlapping it, for the arms.

2.

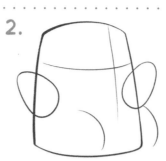

Add two parallel curves at the base of the body for the legs.

3.

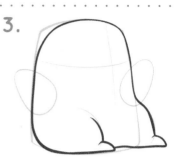

Refine the shape of the head/body and legs using the lines as guides. Add pointy claws to the legs.

4.

Refine the shape of the arms, having them also end in pointy claws.

5.

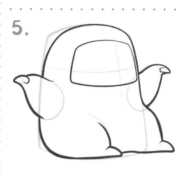

Draw a smaller trapezoid to define the markings on the face.

6.

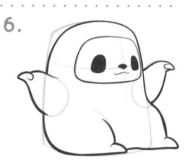

Place the eyes, nose, and mouth following the facial guidelines. Make the eyes arches, the nose a rounded triangle, and the mouth a wavy line.

7.

Add curves around the eyes for more markings.

8.

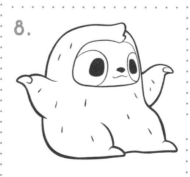

Finish your sloth with a tuft of fur on top of its head. Draw short lines all over its body to make it extra furry.

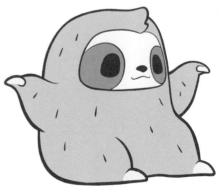

ZEBRA

1.

Draw an oval for the head, with guidelines in the direction the zebra is facing.

2.

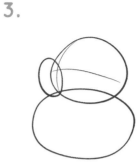

Add a smaller oval to the left side of the head for the snout.

3.

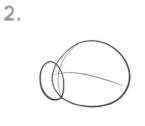

Draw a larger oval, overlapping the head, for the body.

4.

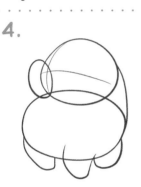

Draw a slightly curved line along the right side, connecting the head and body. Add three legs as U shapes.

5.

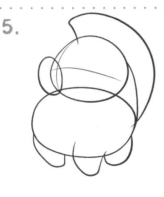

Draw an arc from the top of the head to the body for the mane.

6.

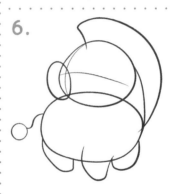

Draw the tail as a skinny, curved line with a circle on the end.

7.

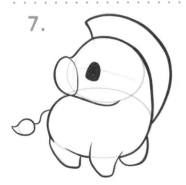

Refine the shape of the zebra using the lines as guides. Add a curved line to define the snout, and place the eye as an arch following the facial guidelines.

8.

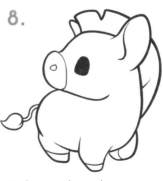

Finish your zebra with texture lines added to the mane and tail, horizontal lines added to the legs for hooves, and a tiny oval on the snout for a nostril.

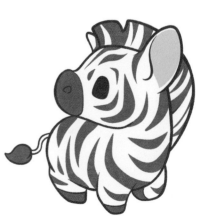

SQUIRREL

1.

Draw a rounded trapezoid for the head, with guidelines in the direction the squirrel is facing.

2.

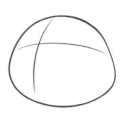

Add two intersecting circles below the head for the haunches.

3.

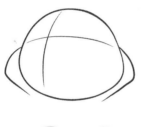

Draw angular curves off the sides of the face for the cheeks.

4.

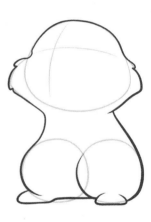

Refine the shape of the head and haunches using the lines as guides. Connect the shapes with curved lines for the body and add feet.

5.

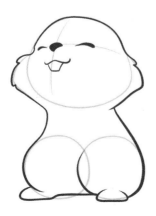

Place the eyes, nose, mouth, and teeth following the facial guidelines. Make the eyes elongated teardrops, the nose a rounded triangle, the mouth a wavy line, and the teeth an incomplete trapezoid.

6.

Draw curved lines on the head for markings.

7.

Add the ears as U shapes, with curved lines inside for the folds.

8.

Draw the front legs as U shapes.

9.

Give your squirrel a large, bushy tail.

10.

If you want, finish your squirrel with an acorn for it to hold!

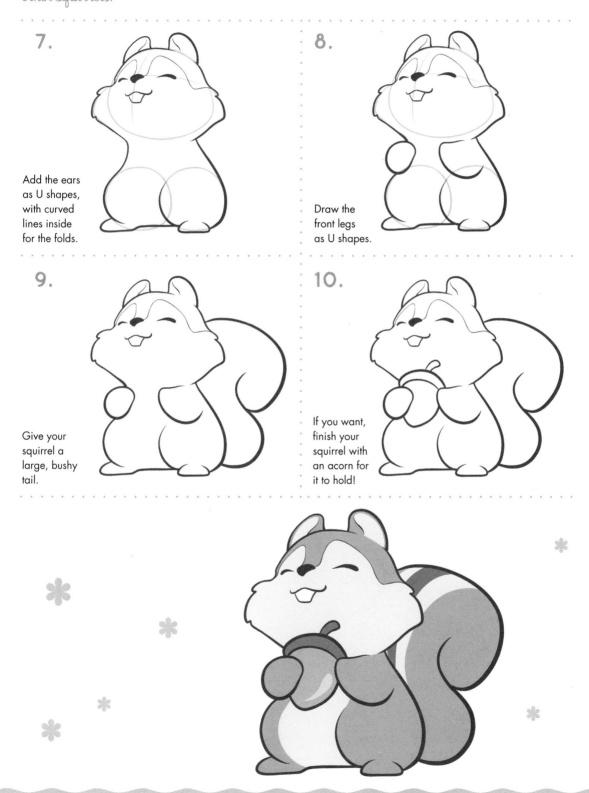

TIGER

1.

Draw a rounded trapezoid for the head, with guidelines in the direction the tiger is facing.

2.

Draw an oblong oval, slightly overlapping the head, for the body.

3.

Draw two smaller ovals, overlapping the top of the head, for the ears.

4.

Refine the shape of the head and body using the lines as guides. Add a curved line to the base of the body for the front legs.

5.

Draw some more curved lines to define the front legs even more.

6.

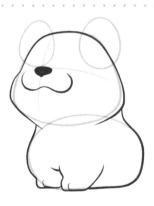

Place the nose and snout following the facial guidelines. Make the nose a rounded triangle and the snout a wavy line.

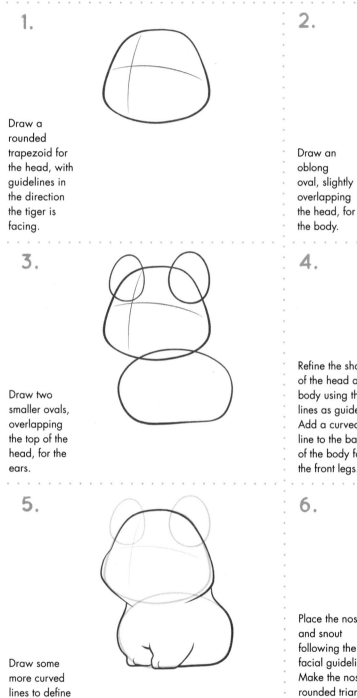

FUN FACT: *The stripe patterns on tigers are unique to each tiger, like human fingerprints, and not only is their fur striped, but also their skin.*

7.

Place the eyes and mouth. Make the eyes elongated teardrops and the mouth a V shape, with a curved line for the tongue and two tiny V shapes for fangs.

8.

Refine the shape of the ears, with curved lines inside for the folds. Add tufts of fur inside the ears.

9.

Add some fur to the sides of the head and to the chest.

10.

Finish your tiger with a long tail in an outlined S shape.

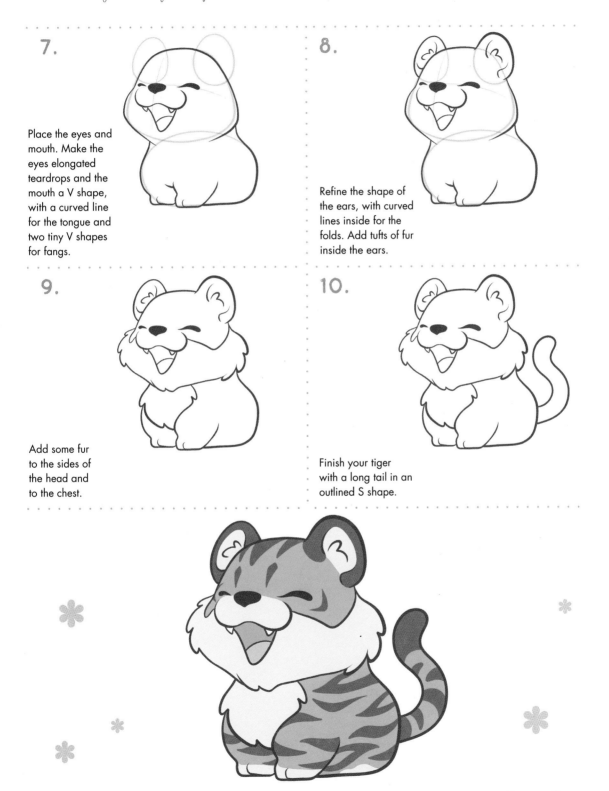

WOLF

1.

Draw an oval for the head, with a guideline in the direction the wolf is facing.

2.

Draw an egg shape below the head for the haunch.

3.

Connect the two shapes with curved lines for the body.

4.

Refine the shape of the head, haunch, and body using the lines as guides. Add the snout to the left side of the head.

5.

Place the eye, nose, and mouth, making the eye an elongated teardrop, the nose a rounded triangle, and the mouth a curved line, with a tiny V shape for a fang.

6.

Add the ears as upside-down V shapes, with curved lines inside for the folds.

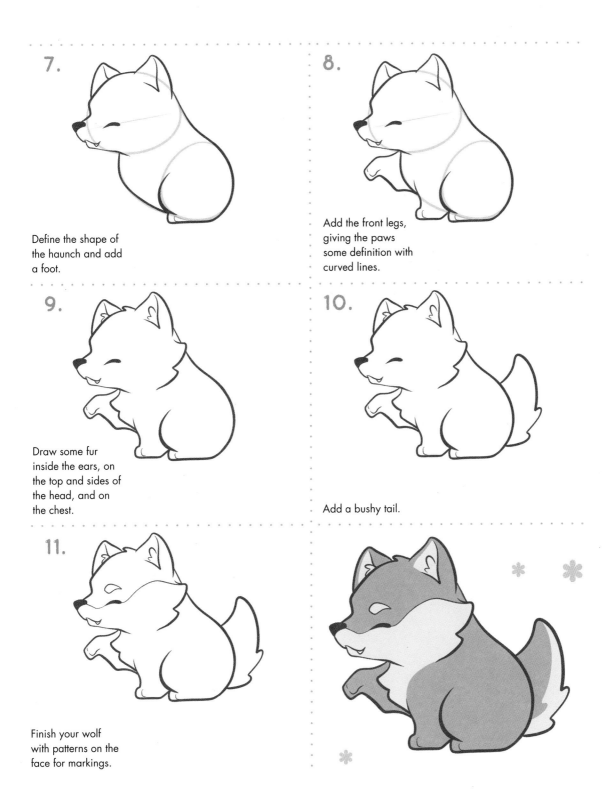

7.

Define the shape of the haunch and add a foot.

8.

Add the front legs, giving the paws some definition with curved lines.

9.

Draw some fur inside the ears, on the top and sides of the head, and on the chest.

10.

Add a bushy tail.

11.

Finish your wolf with patterns on the face for markings.

AQUATIC & SEMIAQUATIC MAMMALS

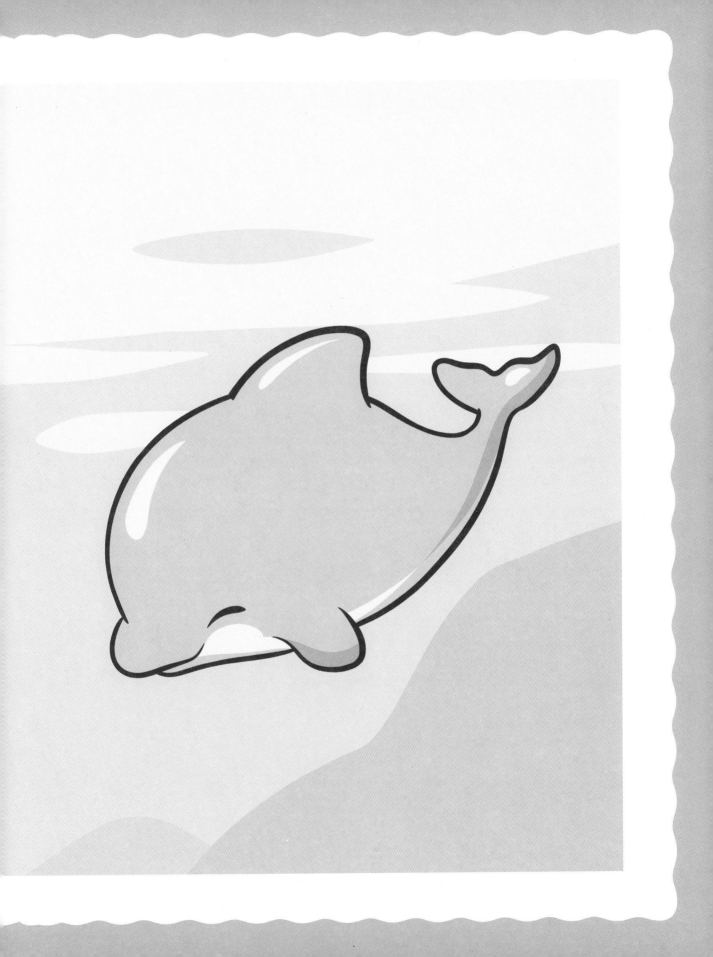

BEAVER

1.

Draw an oval for the head, with guidelines in the direction the beaver is facing.

2.

Draw a circle and a semicircle below the head for the body.

3.

Refine the shape of the head and body using the lines as guides.

4.

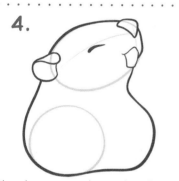

Place the eye as an elongated teardrop, the nose as a rounded trapezoid, and the mouth as an upside-down V shape, with a protruding tooth.

5.

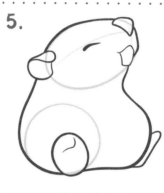

Draw an oval for the front foot and a curved line for the back foot. Add a wavy line to the front foot for detail.

6.

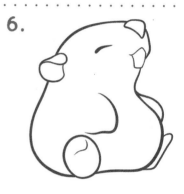

Add two curves for the arms.

7.

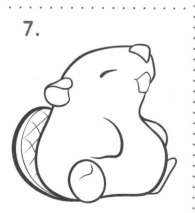

Draw a thick curve for the tail, adding a parallel line for depth and a crisscross pattern for texture.

8.

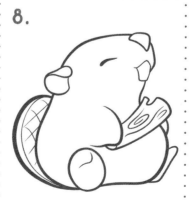

If you want, finish your beaver by having it hold a log!

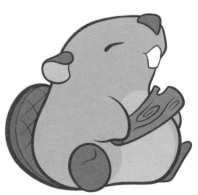

DOLPHIN

1.

Draw a large oval for the head/body, with a guideline in the direction the dolphin is facing.

2.

Draw a small semicircle to the right of the body/head for the tail.

3.

Refine the shape of the head/body using the lines as guides.

4.

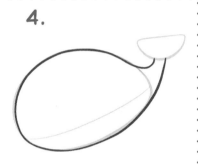

Connect the body to the tail with curved lines.

5.

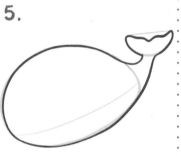

Refine the shape of the tail. Add a U-shaped notch in the middle to define the flukes.

6.

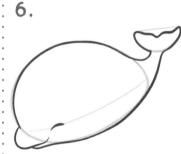

Place the eye and snout following the facial guidelines. Make the eye an elongated teardrop, the snout a U shape, and the mouth a curved line.

7.

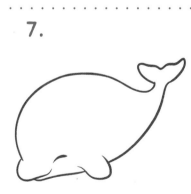

Add the pectoral fin on the side of the body as a U shape.

8.

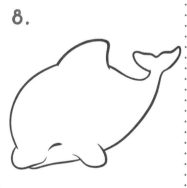

Finish your dolphin with the dorsal fin on top as an upside-down V shape.

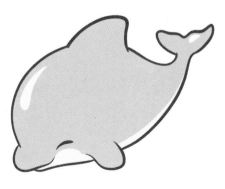

HIPPOPOTAMUS

1.

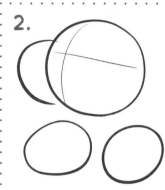

Draw a circle for the head, with guidelines in the direction the hippopotamus is facing.

2.

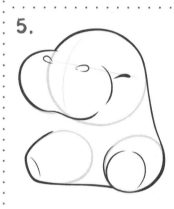

Add a curve off the left side of the head for the snout and two ovals below the head for the back legs.

3.

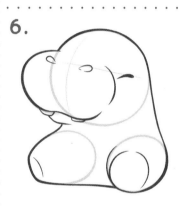

Refine the shape of the head, snout, and legs. Connect the shapes with a curved line. Add the right side of the snout.

4.

Place the eye and nostrils, making the eye an elongated teardrop and the nostrils regular teardrops.

5.

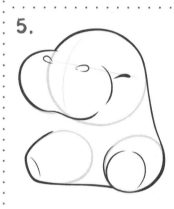

Add curved lines to the legs for hooves.

6.

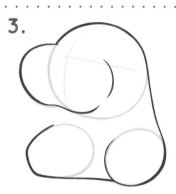

Draw a curved line for the chin and short U shapes for the teeth.

7.

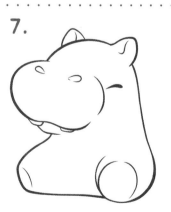

Add upside-down V shapes for the ears, with curved lines inside for the folds.

8.

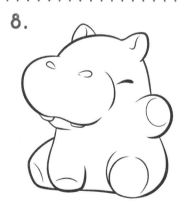

Finish your hippopotamus with the front arms drawn as U shapes. Add curved lines for hooves.

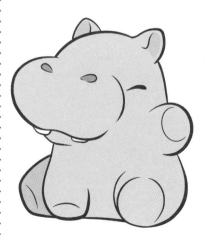

MANATEE

1.

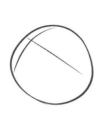

Draw an oval for the head, with guidelines in the direction the manatee is facing.

2.

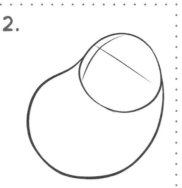

Draw a large U shape off the head for the body, giving your manatee a jelly-bean shape.

3.

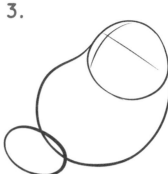

Add a small oval below the body for the tail.

4.

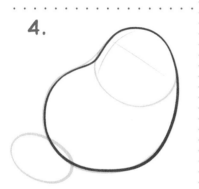

Refine the shape of the head and body using the lines as guides and keeping that jelly-bean shape.

5.

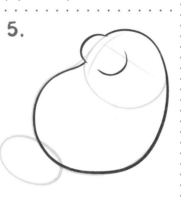

Draw two curves on the head for the snout.

6.

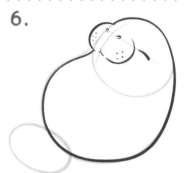

Place the eye and nostrils, making the eye an elongated teardrop and the nostrils tiny, upside-down U shapes. Add some dots to the snout for hair follicles.

7.

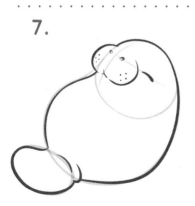

Refine the shape of the tail. It should have a rounded paddle-like shape.

8.

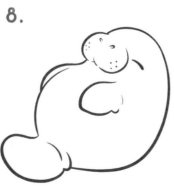

Finish your manatee with some flippers. Make the one on the right side a U shape and the one on the left a curved line.

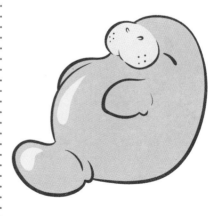

MOOSE

1.

Draw a circle for the head, with guidelines in the direction the moose is facing.

2.

Add a small oval, overlapping the lower-right side of the head, for the snout.

3.

Draw a larger oval below the head for the body.

4.

Refine the shape of the head and snout using the lines as guides. Give the moose a furry neck and chest.

5.

Place the eye and nostrils following the facial guidelines. Make the eye an arch and the nostrils tiny C shapes.

6.

Add the ears as upside-down U shapes, with curved lines inside for the folds.

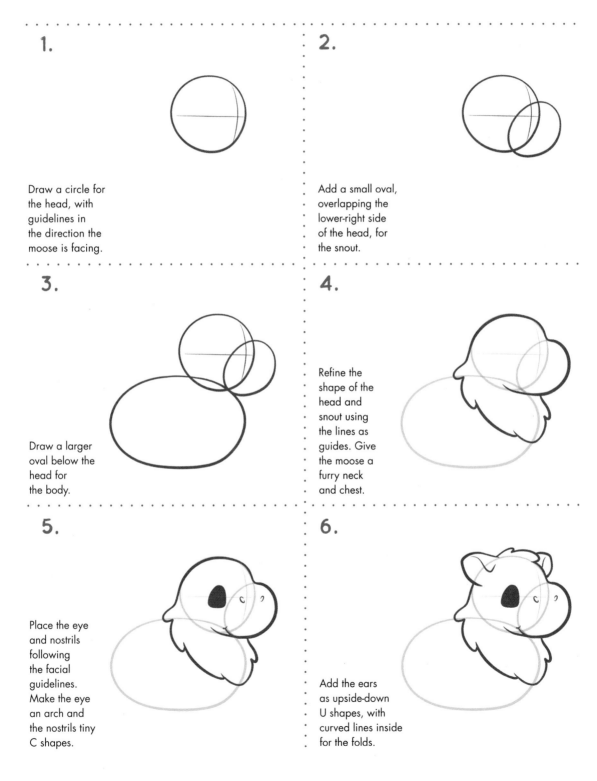

FUN FACT: *Moose enjoy swimming and can dive down 20 feet (6 m) in the water and hold their breath for 30 seconds. They also can close their nostrils to keep out any water while grazing for plants in the water.*

7.

Refine the shape of the body, adding four stout U shapes for the legs.

8.

Add lines to the legs for hooves, along with a short, fluffy tail.

9.

Finish your moose with some impressive antlers.

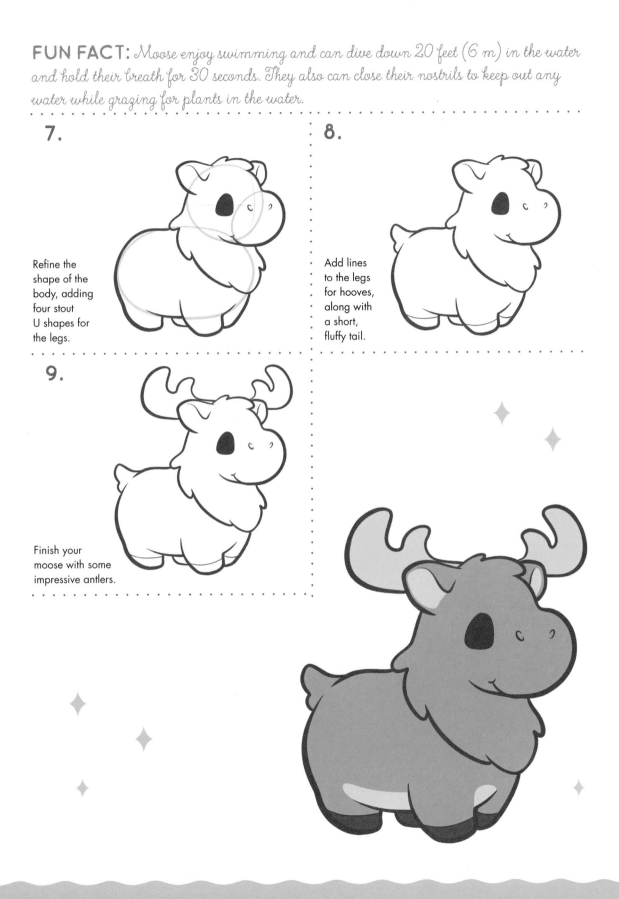

NARWHAL

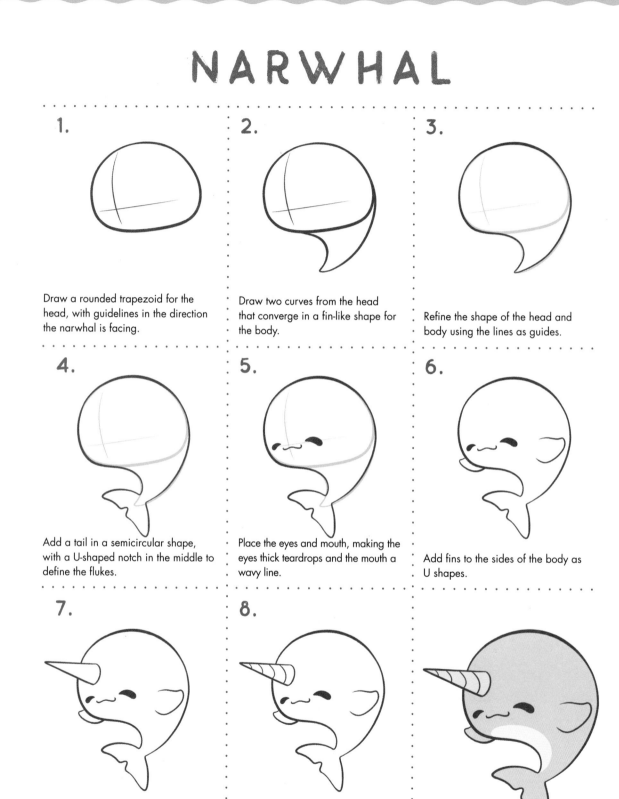

1. Draw a rounded trapezoid for the head, with guidelines in the direction the narwhal is facing.

2. Draw two curves from the head that converge in a fin-like shape for the body.

3. Refine the shape of the head and body using the lines as guides.

4. Add a tail in a semicircular shape, with a U-shaped notch in the middle to define the flukes.

5. Place the eyes and mouth, making the eyes thick teardrops and the mouth a wavy line.

6. Add fins to the sides of the body as U shapes.

7. Draw the pointy tusk off the forehead as a triangle, with a curved line at its base for depth.

8. Finish your narwhal by adding the spiral detail to its tusk.

ORCA

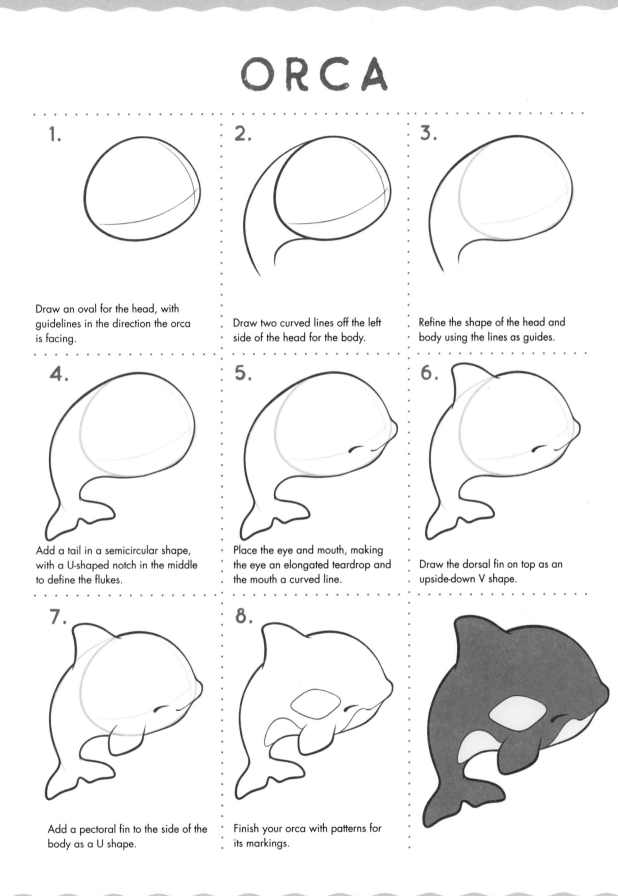

1. Draw an oval for the head, with guidelines in the direction the orca is facing.

2. Draw two curved lines off the left side of the head for the body.

3. Refine the shape of the head and body using the lines as guides.

4. Add a tail in a semicircular shape, with a U-shaped notch in the middle to define the flukes.

5. Place the eye and mouth, making the eye an elongated teardrop and the mouth a curved line.

6. Draw the dorsal fin on top as an upside-down V shape.

7. Add a pectoral fin to the side of the body as a U shape.

8. Finish your orca with patterns for its markings.

OTTER

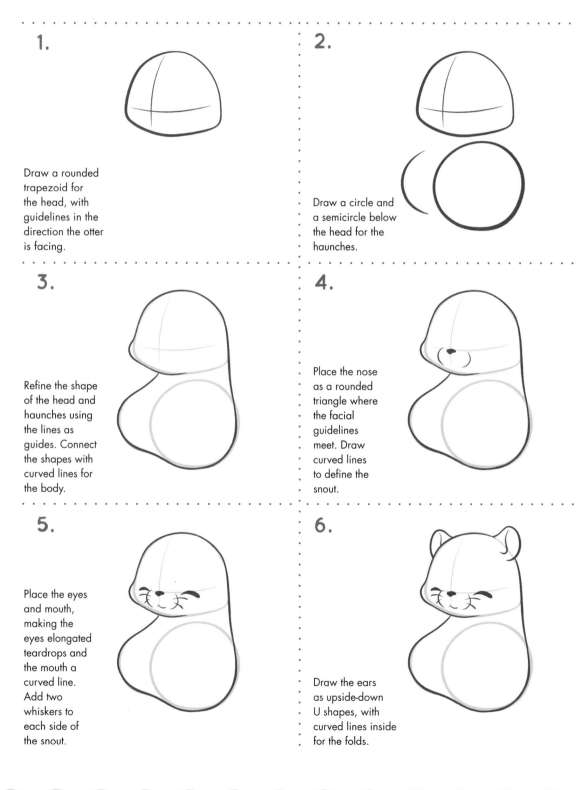

1.

Draw a rounded trapezoid for the head, with guidelines in the direction the otter is facing.

2.

Draw a circle and a semicircle below the head for the haunches.

3.

Refine the shape of the head and haunches using the lines as guides. Connect the shapes with curved lines for the body.

4.

Place the nose as a rounded triangle where the facial guidelines meet. Draw curved lines to define the snout.

5.

Place the eyes and mouth, making the eyes elongated teardrops and the mouth a curved line. Add two whiskers to each side of the snout.

6.

Draw the ears as upside-down U shapes, with curved lines inside for the folds.

FUN FACT: Otters are known to use tools, such as rocks to help open food in shells. They also store these tools with their food in the loose pockets of skin under their armpits.

7.

Add the front paws as U shapes.

8.

Draw some cute, little feet.

9.

Finish your otter with a thick, curved tail.

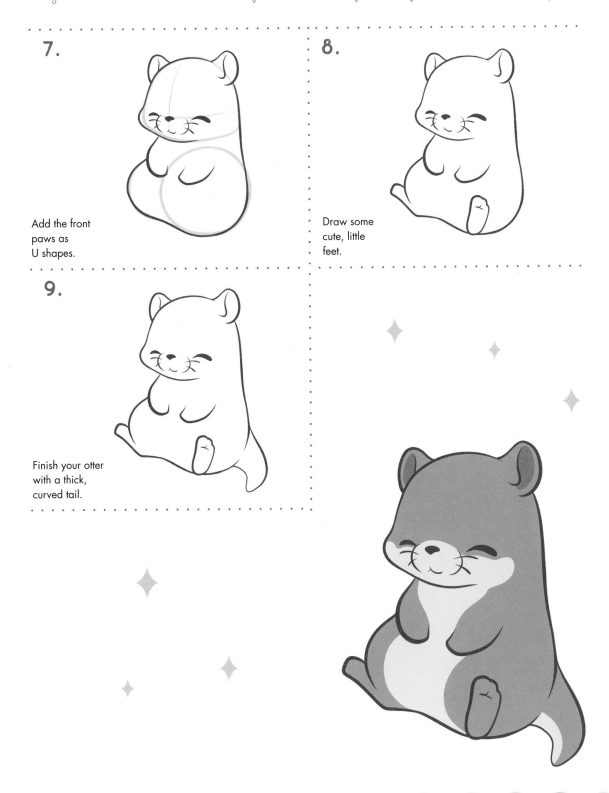

PLATYPUS

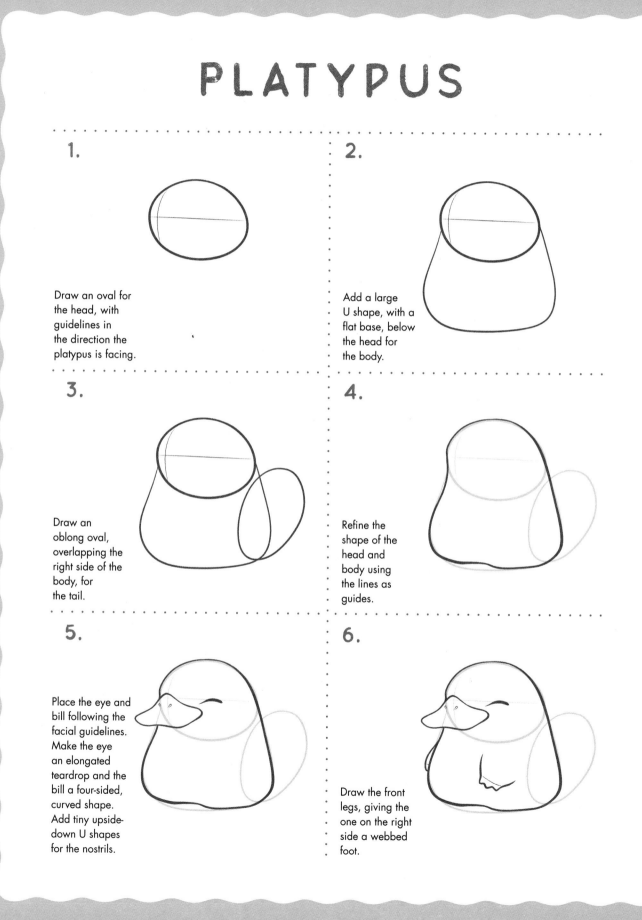

1.

Draw an oval for the head, with guidelines in the direction the platypus is facing.

2.

Add a large U shape, with a flat base, below the head for the body.

3.

Draw an oblong oval, overlapping the right side of the body, for the tail.

4.

Refine the shape of the head and body using the lines as guides.

5.

Place the eye and bill following the facial guidelines. Make the eye an elongated teardrop and the bill a four-sided, curved shape. Add tiny upside-down U shapes for the nostrils.

6.

Draw the front legs, giving the one on the right side a webbed foot.

FUN FACT: *The platypus doesn't have teeth, so it uses gravel to help break up food in its mouth.*

7.

Add the back feet, also making them webbed.

8.

Refine the shape of the tail. Add a parallel line inside to give it depth.

9.

Finish your platypus by adding a crisscross pattern to the tail.

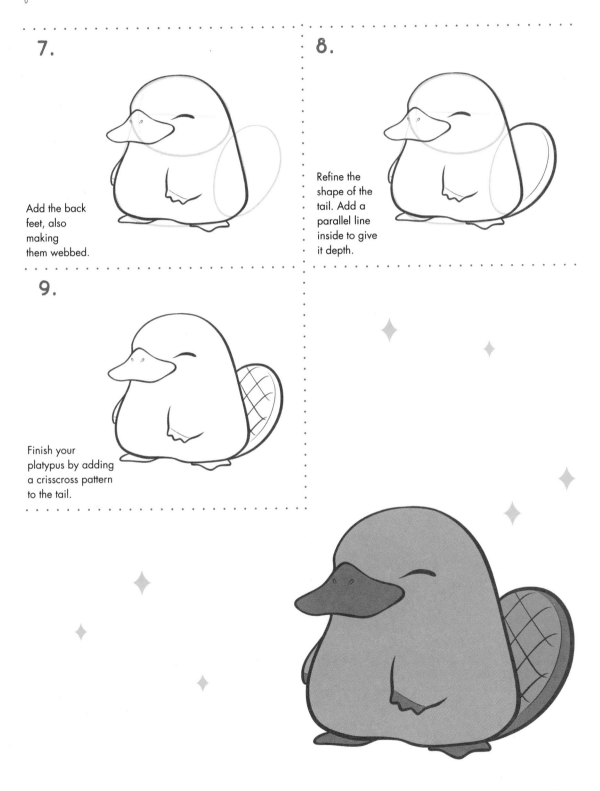

SEAL

1.

Draw a circle for the head, with a guideline in the direction the seal is facing.

2.

Draw a large oval, overlapping the head, for the body.

3.

Refine the shape of the head and body using the lines as guides. Add the snout to the left side of the head.

4.

Place the eye, nose, and mouth, making the eye an elongated teardrop, the nose a small U shape, and the mouth two curved lines.

5.

Draw the back flippers, adding lines for definition.

6.

Finish your seal with the front flippers. Draw a wide U shape for the one on the right side and a curved line for the one on the left.

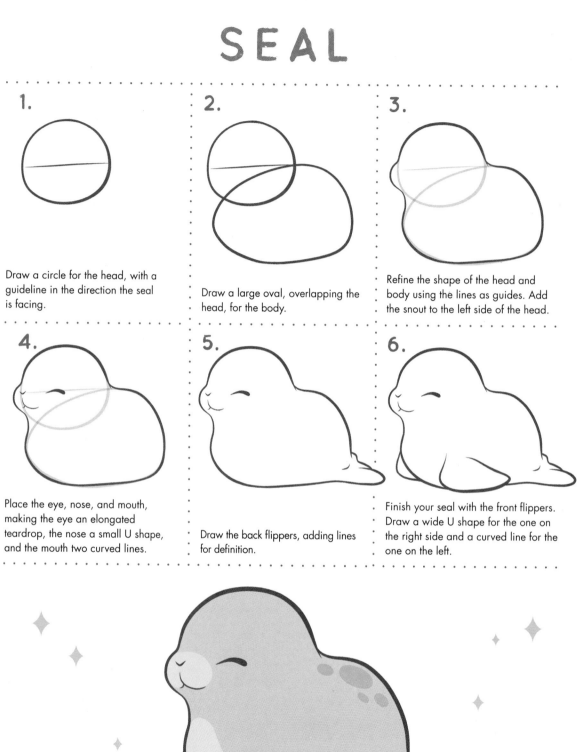

WHALE

1.

Draw a large, rounded trapezoid for the head/body, with guidelines in the direction the whale is facing.

2.

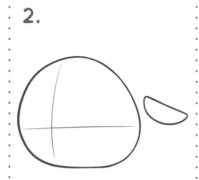

Draw a small semicircle to the right of the head/body for the tail.

3.

Connect the two shapes with curved lines.

4.

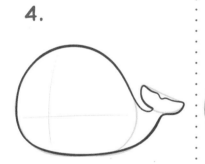

Refine the shape of the head/body and tail using the lines as guides. Add a U-shaped notch in the middle of the tail to define the flukes.

5.

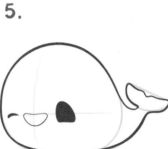

Place the eyes and mouth, making one eye an elongated teardrop and the other an arch. Draw the mouth as a wide, rounded triangle.

6.

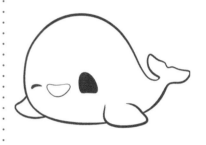

Add fins to the sides of the body as U shapes.

7.

Finish your whale with water spouting out of its blowhole.

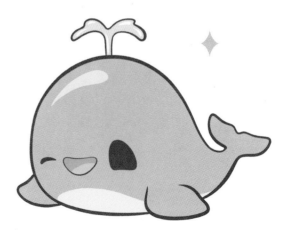

BIRDS

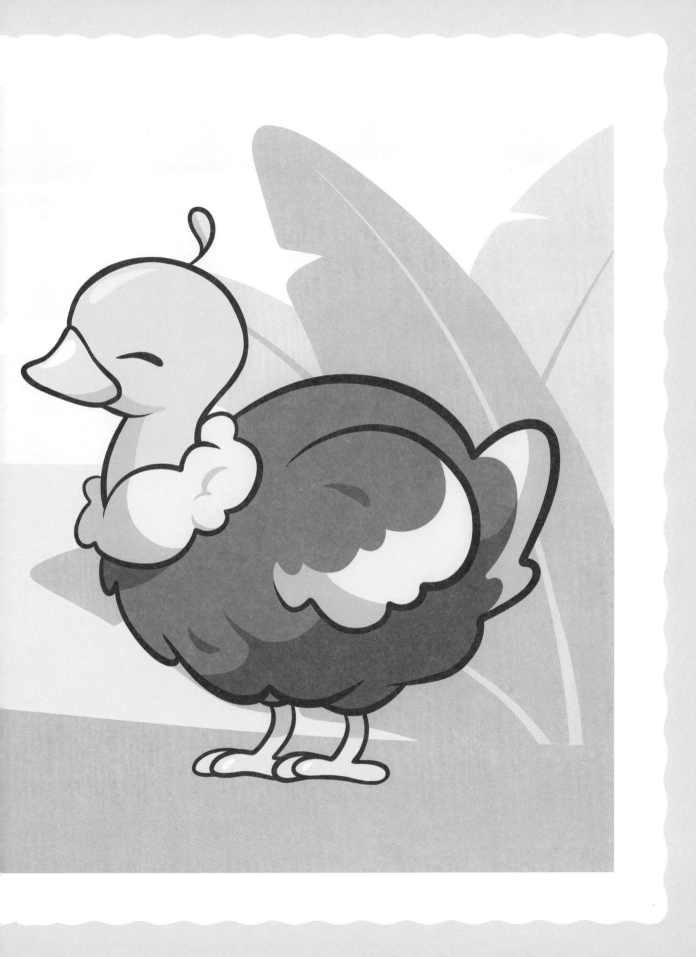

CHICKEN

1.

Draw an oval for the head, with a guideline in the direction the chicken is facing.

2.

Draw a larger oval shape, overlapping the head, for the body.

3.

Refine the shape of the head using the lines as guides. Add neck feathers to the lower part of the head.

4.

Refine the shape of the body, making the base flat with some feather details. Add a squiggly line to the left side of the body for a wing.

5.

Place the eye and beak following the facial guideline. Make the eye an elongated teardrop and the beak a bulbous oval.

6.

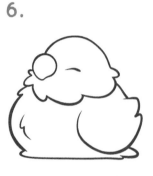

Add the wing to the right side of the body as a U shape, giving it some feathers.

7.

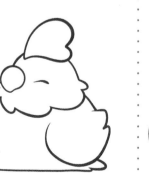

Draw the comb on top of the head as a heart shape.

8.

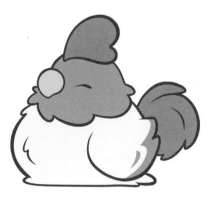

Finish your chicken with some fluffy tail feathers.

COCKATIEL

1.

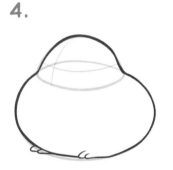

Draw a semicircle for the head, with guidelines in the direction the cockatiel is facing.

2.

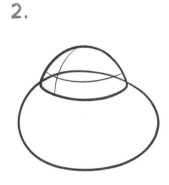

Draw a large oval, overlapping the head, for the body.

3.

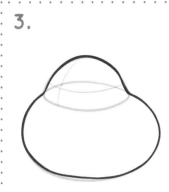

Refine the shape of the head and body using the lines as guides.

4.

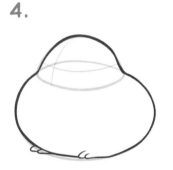

Draw the feet, adding lines for definition.

5.

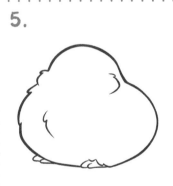

Add some feathers to the head and body.

6.

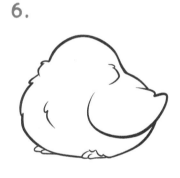

Draw the wing on the right side, giving it some feathers.

7.

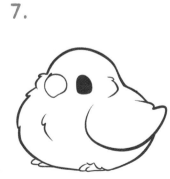

Place the eyes and beak, making the front eye an arch and the beak a bulbous oval. Just give a hint of the other eye.

8.

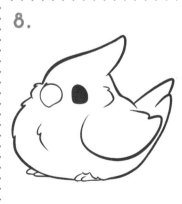

Finish your cockatiel with some head and tail feathers.

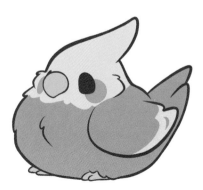

DUCK

Draw an oval for the head, with a
guideline in the direction the
duck is facing.

2.

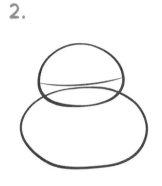

Draw a larger oval, overlapping the
head, for the body.

3.

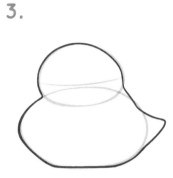

Refine the shape of the head and
body. Add a point to the back of the
body for the tail.

4.

Place the eye and bill following the
facial guidelines. Make the eye an
elongated teardrop and the bill a four-
sided, curved shape.

5.

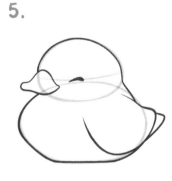

Add the wing as a large U shape.

6.

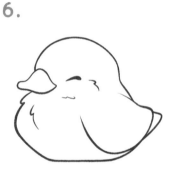

Draw some feathers on the face and chest.

7.

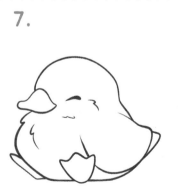

Add the feet, making the one on the
right side webbed.

8.

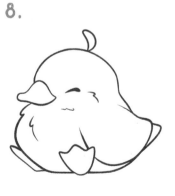

Finish your duck with a feather on
top of the head.

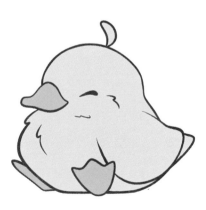

KIWI

1.

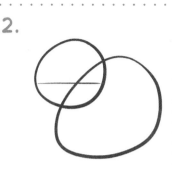

Draw an oval for the head, with a guideline in the direction the kiwi is facing.

2.

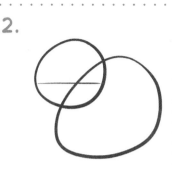

Add a larger oval, overlapping the right side of the head, for the body.

3.

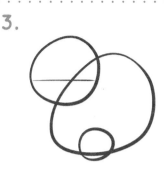

Add a smaller oval inside the body for the thigh.

4.

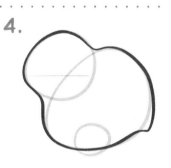

Refine the shape of the head and body using the lines as guides. Add a point to the back of the body for the tail.

5.

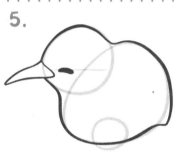

Place the eye and beak following the facial guidelines. Make the eye a thick curve and the beak a long, pointy triangle.

6.

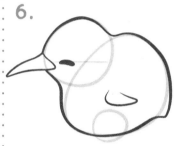

Add a tiny wing as a U shape.

7.

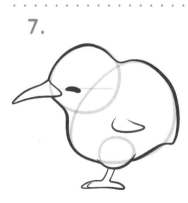

Refine the shape of the thigh, and then add the leg and foot as an upside-down, outlined T shape.

8.

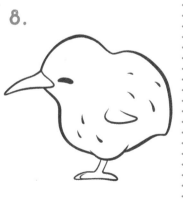

Finish your kiwi with some feathers, by drawing elongated teardrop shapes all over its body.

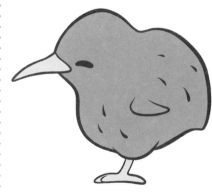

OSTRICH

1.

Draw a small oval for the head, with a guideline in the direction the ostrich is facing.

2.

Draw a much larger oval below the head for the body.

3.

Add a smaller oval inside the body for the wing.

4.

Refine the shape of the head using the lines as guides. Connect the head to the body with curved lines for the neck.

5.

Place the eye and beak following the facial guidelines. Make the eye an elongated teardrop and the beak a rounded triangle.

6.

Add some neck feathers, like a collar.

7.

Refine the shape of the body, while also making it fluffy.

8.

Refine the shape of the wing, also making it fluffy.

9.

Add the legs and talons as upside-down, outlined T shapes.

10.

Finish your ostrich with a little feather on top of the head.

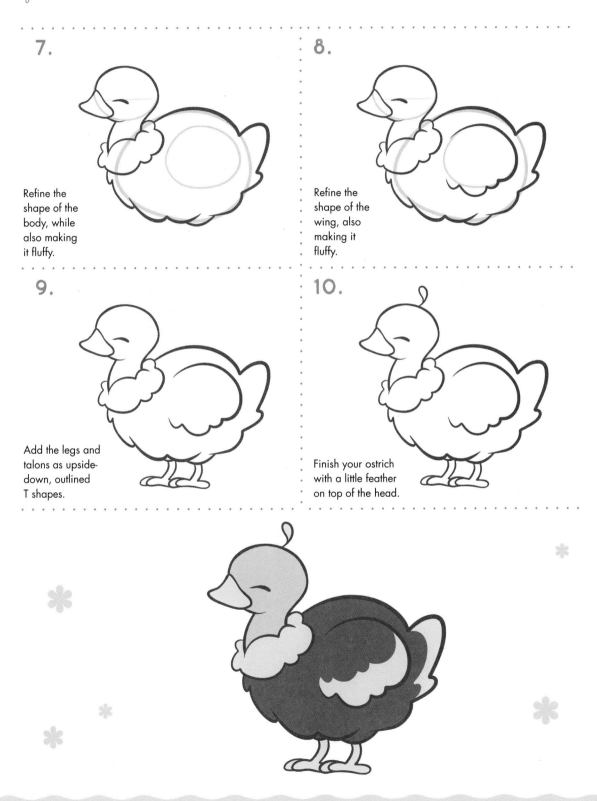

OWL

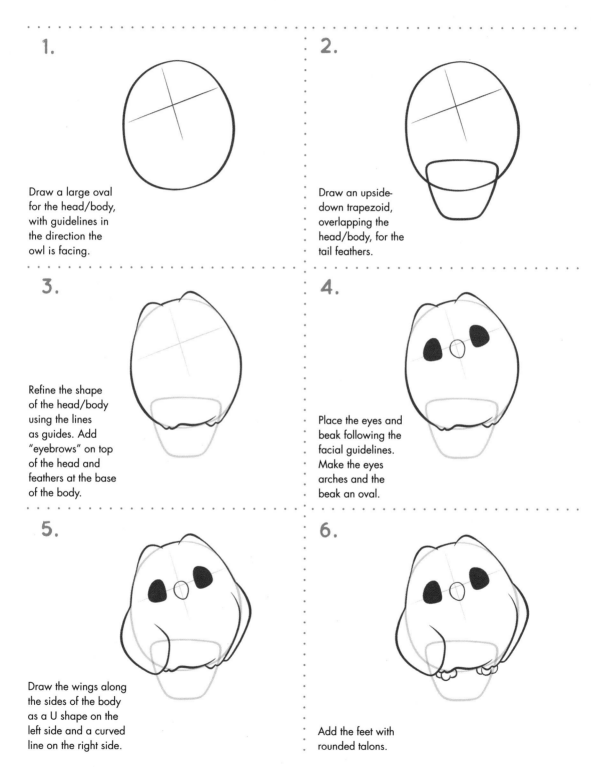

1.

Draw a large oval for the head/body, with guidelines in the direction the owl is facing.

2.

Draw an upside-down trapezoid, overlapping the head/body, for the tail feathers.

3.

Refine the shape of the head/body using the lines as guides. Add "eyebrows" on top of the head and feathers at the base of the body.

4.

Place the eyes and beak following the facial guidelines. Make the eyes arches and the beak an oval.

5.

Draw the wings along the sides of the body as a U shape on the left side and a curved line on the right side.

6.

Add the feet with rounded talons.

FUN FACT: *How can owls turn their heads 270 degrees without cutting off circulation? They have reservoirs at the tops of their spines where blood pools and is supplied to their brains.*

7.

Give the head and chest some feathers.

8.

Draw the ears behind the "eyebrows" as upside-down V shapes, with some feather details around them.

9.

Refine the shape of the tail feathers using the lines as guides. Make them a little jagged so they look feather-like.

10.

If you want, finish your owl by adding a branch!

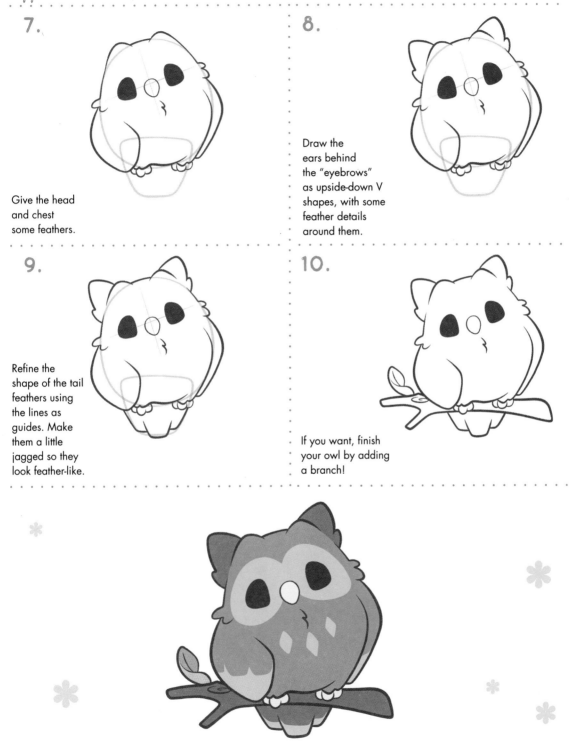

PEACOCK

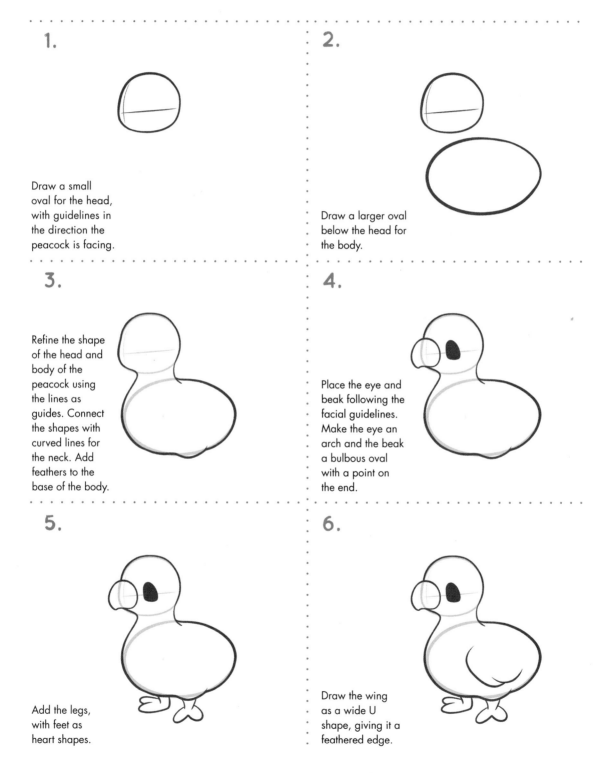

1.

Draw a small oval for the head, with guidelines in the direction the peacock is facing.

2.

Draw a larger oval below the head for the body.

3.

Refine the shape of the head and body of the peacock using the lines as guides. Connect the shapes with curved lines for the neck. Add feathers to the base of the body.

4.

Place the eye and beak following the facial guidelines. Make the eye an arch and the beak a bulbous oval with a point on the end.

5.

Add the legs, with feet as heart shapes.

6.

Draw the wing as a wide U shape, giving it a feathered edge.

FUN FACT: *Technically, only the male is called a peacock (a female is called a peahen) and has the bright, iridescent feathers, which peak in beauty around the age of five or six.*

7.

Add the first feather for the peacock's impressive tail plumage above the wing.

8.

Draw more tail feathers off the back and to the left of the body.

9.

Add lines to the feathers to give them definition.

10.

Add some shorter feathers in front of the tail feathers.

11.

Finish your peacock with two feathers on top of its head.

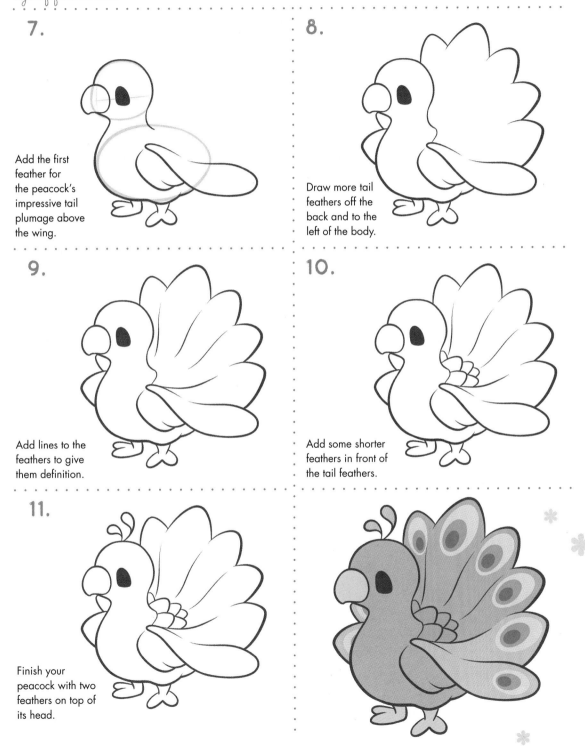

PENGUIN

1.

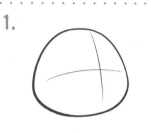

Draw a rounded trapezoid for the head, with guidelines in the direction the penguin is facing.

2.

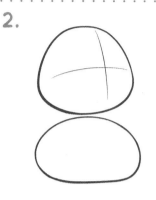

Draw an oval, slightly smaller than the head, for the body.

3.

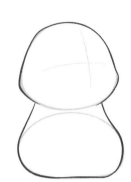

Refine the shape of the head and body. Connect the shapes with slightly curved lines.

4.

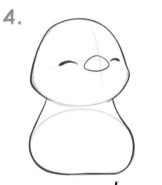

Place the eyes and beak, making the eyes elongated teardrops and the nose a wide, rounded triangle.

5.

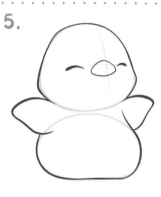

Add the wings as V shapes.

6.

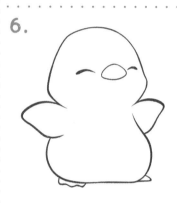

Draw the webbed feet.

7.

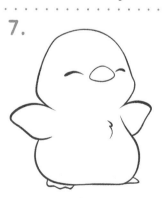

Add some fur to the chest.

8.

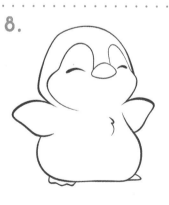

Finish your penguin with curved lines on the face for its markings.

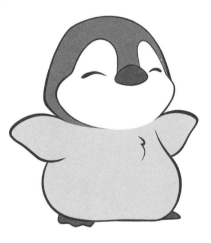

SWAN

1.

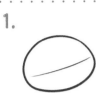

Draw a small oval for the head, with a guideline in the direction the swan is facing.

2.

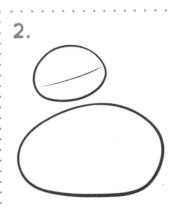

Draw a much larger oval below the head for the body.

3.

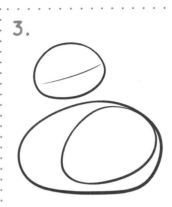

Add a smaller oval inside the body for the wing.

4.

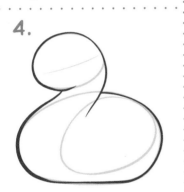

Refine the shape of the head and body. Connect the shapes with curved lines for the neck.

5.

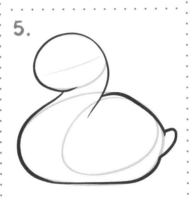

Add a tail as an upside-down U shape.

6.

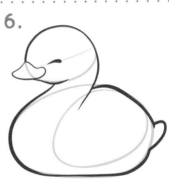

Place the eye and bill, making the eye an elongated teardrop and the bill a four-sided, curved shape.

7.

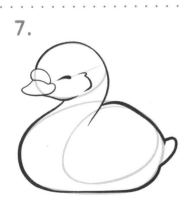

Add an arched line above the bill for the basal knob, along with some feathers on the face.

8.

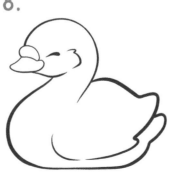

Finish your swan by refining the shape of the wing and giving it feathered edges.

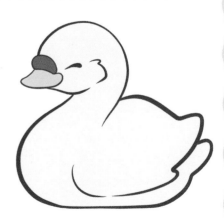

TOUCAN

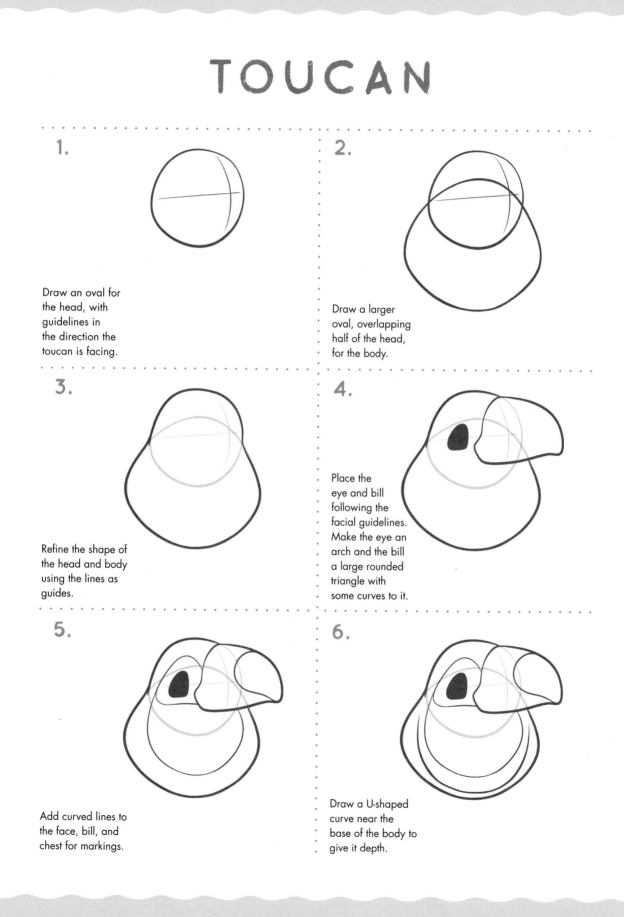

1.

Draw an oval for the head, with guidelines in the direction the toucan is facing.

2.

Draw a larger oval, overlapping half of the head, for the body.

3.

Refine the shape of the head and body using the lines as guides.

4.

Place the eye and bill following the facial guidelines. Make the eye an arch and the bill a large rounded triangle with some curves to it.

5.

Add curved lines to the face, bill, and chest for markings.

6.

Draw a U-shaped curve near the base of the body to give it depth.

FUN FACT: *In proportion to its body, the toucan has the largest bill of any bird. Fortunately, it's lightweight because it's made of keratin, the protein of human hair and nails.*

7.

Add the talons to the base of the body.

8.

Draw a branch for those talons to grip.

9.

Finish your toucan with some textured tail feathers.

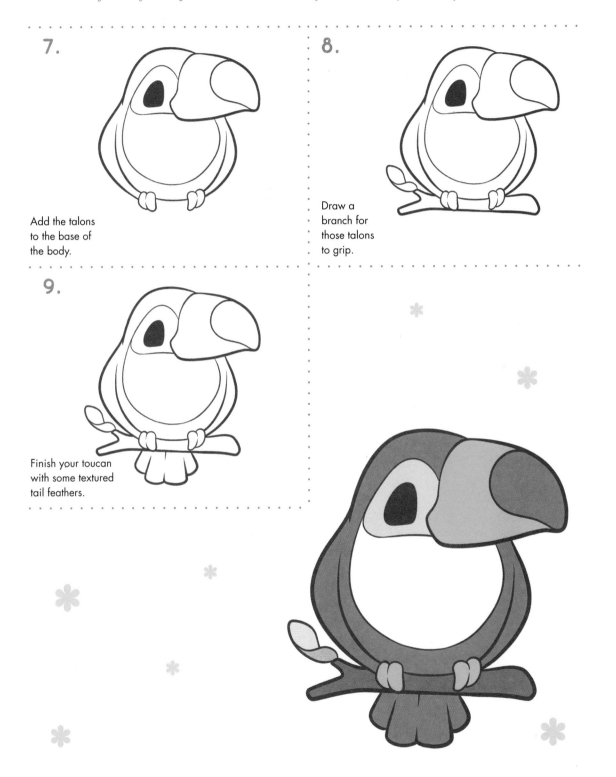

AMPHIBIANS, FISH, REPTILES & MORE

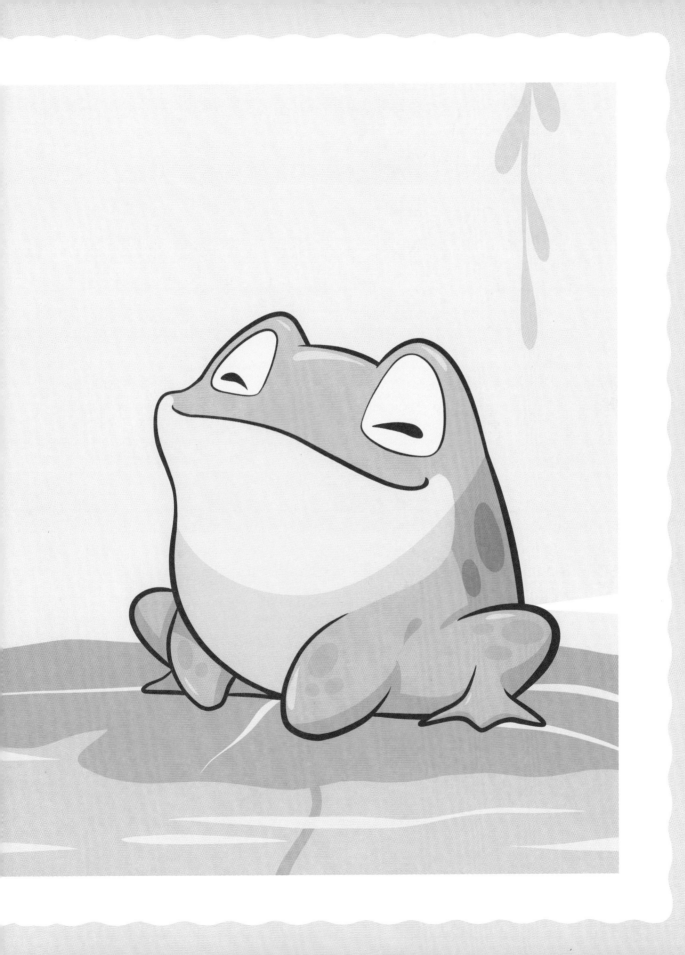

ALLIGATOR

1.

Draw a large, slanted triangle, with rounded points for the head/body.

2.

Add a small oval not quite halfway down the back of the body that overlaps it.

3.

Draw two small ovals at the base of the body for the legs. Add a curve at the bottom right of the body for a third leg.

4.

Draw a V shape off the bottom left of the body for the tail.

5.

Refine the shape of the head, body, and tail using the lines as guides. Add the snout and a curved line for the mouth.

6.

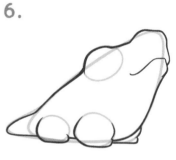

Refine the shape of the legs, making them flat on their bottoms with curved lines defining them.

7.

Add the eye and nostrils in varying sizes of a teardrop shape.

8.

Finish your alligator with four upside-down V shapes along the back for the scutes. Define the underside with curved lines.

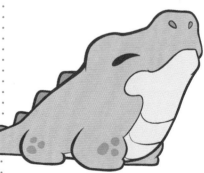

AXOLOTL

1.

Draw an oval for the head, with guidelines in the direction the axolotl is facing.

2.

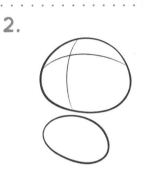

Add a smaller oval below the head for the body.

3.

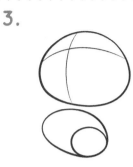

Draw an even smaller oval inside the body for a back leg.

4.

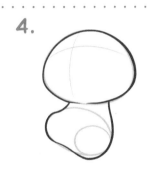

Refine the shape of the head and body using the lines as guides. It should look like a mushroom.

5.

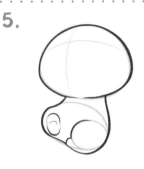

Refine the shape of the back leg on the right and draw an oval with a curved line inside of it for the other back leg.

6.

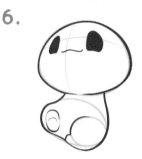

Place the eyes and mouth following the facial guidelines. Make the eyes arches and the mouth a wavy line.

7.

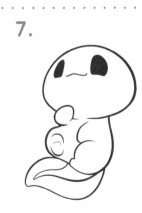

Add a thick tail with a pointy, curved triangular shape inside of it and arms as U shapes.

8.

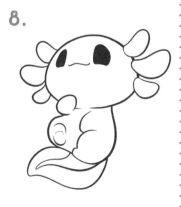

Finish your axolotl with three of its distinctive gills on each side of its head.

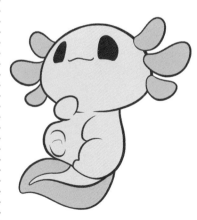

BEE

1.

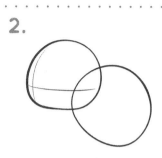

Draw an oval for the head, with guidelines in the direction the bee is facing.

2.

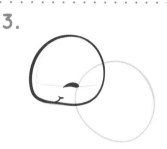

Add a larger oval, overlapping the right side of the head, for the body.

3.

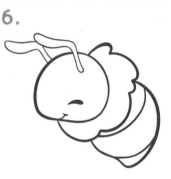

Refine the shape of the head using the lines as guides. Place the eye and mouth following the facial guidelines. Make the eye an elongated teardrop and the mouth a short, curved line.

4.

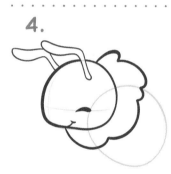

Add fur below the head for the neck and two antennas on the head as upside-down, outlined L shapes.

5.

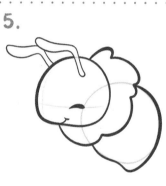

Refine the shape of the body using the lines as guides, giving the base of the body a rounded point.

6.

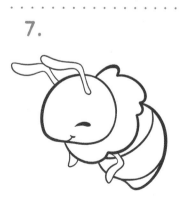

Add segments to the body with two curved lines.

7.

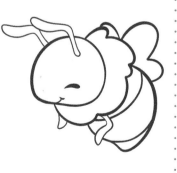

Draw two arms in the same way as you did the antennas.

8.

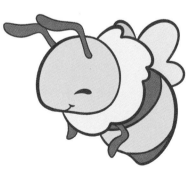

Finish your bee with wings drawn like flower petals.

CHAMELEON

1.

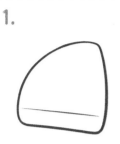

Draw a rounded triangle for the head, with a guideline in the direction the chameleon is facing.

2.

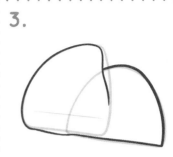

Add a semioval, overlapping the right side of the head, for the body.

3.

Refine the shape of the head and body using these lines as guides.

4.

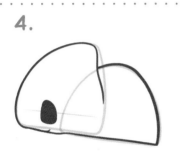

Place the eye and mouth following the facial guideline. Make the eye an arch and the mouth a tiny, curved line.

5.

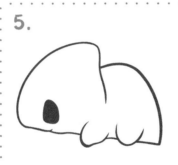

Add two short legs as U shapes.

6.

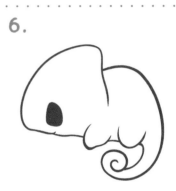

Draw a spiral below the body, connecting to the back of the body, for the tail.

7.

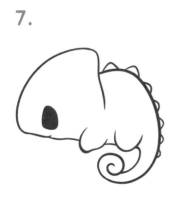

Draw seven upside-down V shapes along the back, going from large to small, for the scales.

8.

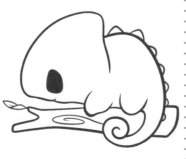

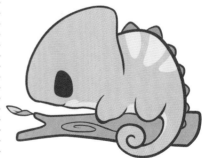

Finish your chameleon by adding a log for it to sit on.

CRAB

1.

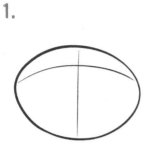

Draw a wide oval for the head/body, with guidelines in the direction the crab is facing.

2.

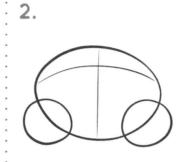

Draw two small circles, overlapping the head/body, for the claws.

3.

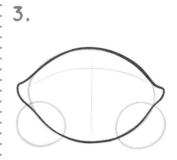

Refine the shape of the head/body using the lines as guides. It should look like a lemon.

4.

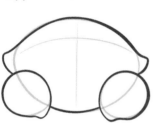

Refine the shape of the claws, giving them some jagged edges.

5.

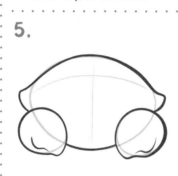

Add wavy lines to the claws to define the shape of them.

6.

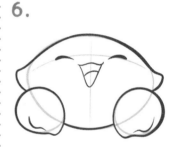

Place the eyes and mouth following the facial guidelines. Make the eyes elongated teardrops and the mouth a triangular shape, with a curved line inside for the tongue.

7.

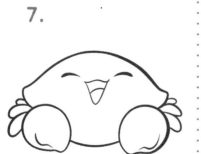

Finish your crab with three more legs on each side of its body.

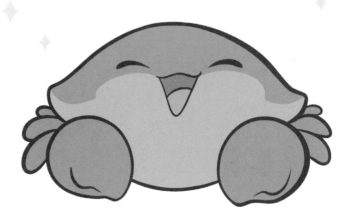

FROG

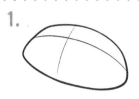

1.

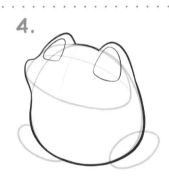

Draw a flat, rounded trapezoid for the head, with guidelines in the direction the frog is facing.

2.

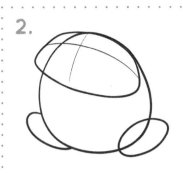

Overlap a large oval with the head for the body and add two smaller ovals at the base of the body for the back legs.

3.

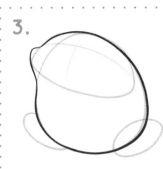

Refine the shape of the head and body using the lines as guides. Add a cheek to the left side of the head.

4.

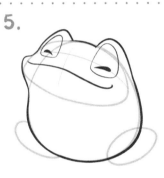

Place the eyes as open arches following the facial guidelines.

5.

Add pupils inside the eyes as elongated teardrops, and draw the mouth as a wide, wavy line.

6.

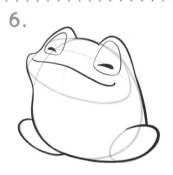

Refine the shape of the back legs using the lines as guides.

7.

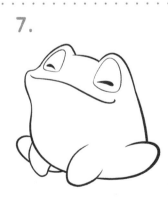

Draw two front legs as U shapes.

8.

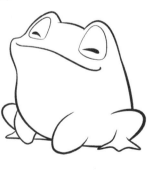

Finish your frog by giving it webbed back feet.

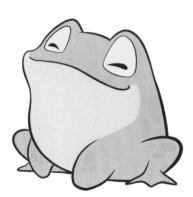

JELLYFISH

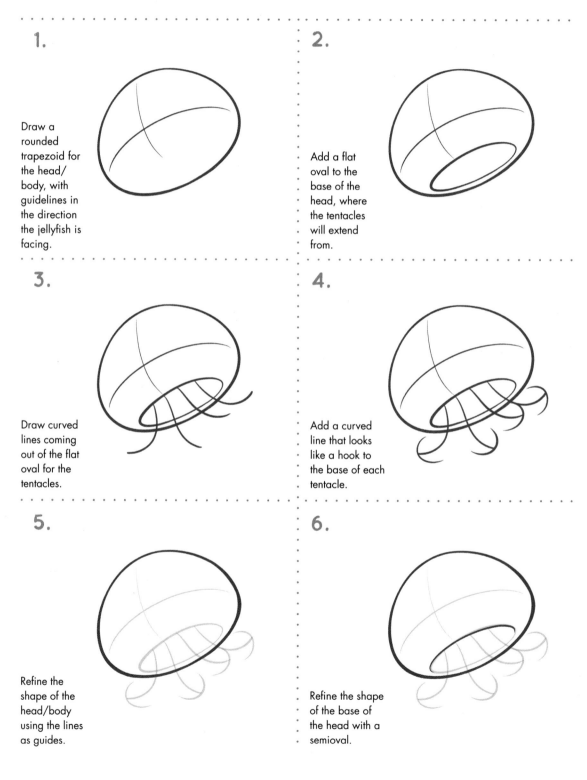

1.

Draw a rounded trapezoid for the head/ body, with guidelines in the direction the jellyfish is facing.

2.

Add a flat oval to the base of the head, where the tentacles will extend from.

3.

Draw curved lines coming out of the flat oval for the tentacles.

4.

Add a curved line that looks like a hook to the base of each tentacle.

5.

Refine the shape of the head/body using the lines as guides.

6.

Refine the shape of the base of the head with a semioval.

7.

Place the eyes and mouth, making the left eye an arch, the right eye an elongated teardrop, and the mouth a slightly wavy line, with a loop for the tongue.

8.

Refine the shape of the tentacles using the lines as guides, starting with the one on the far left.

9.

Refine the shape of the next tentacle, connecting it with the first one.

10.

Continue refining the shape of the third tentacle.

11.

Finish your jellyfish by drawing its last tentacle.

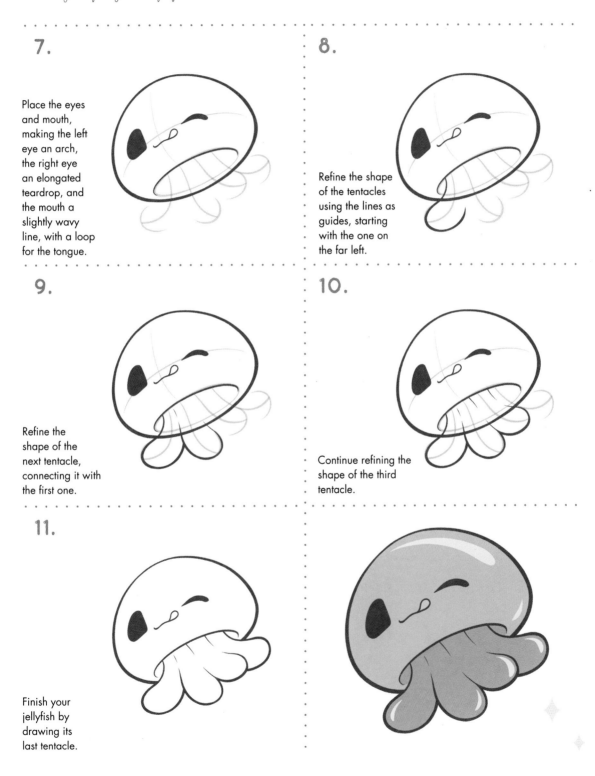

MANTA RAY

1.

Draw a flat oval for the head/body, with guidelines in the direction the manta ray is facing.

2.

Refine the shape of the head/body using the lines as guides and give it wings.

3.

Add its distinctive tail.

4.

Place the eyes and mouth following the facial guidelines. Make the eyes arches and the mouth a wavy line.

5.

Add the detail of the fold above the tail with a curved line.

6.

Finish your manta ray with three wide V-shaped gills on each side of the body.

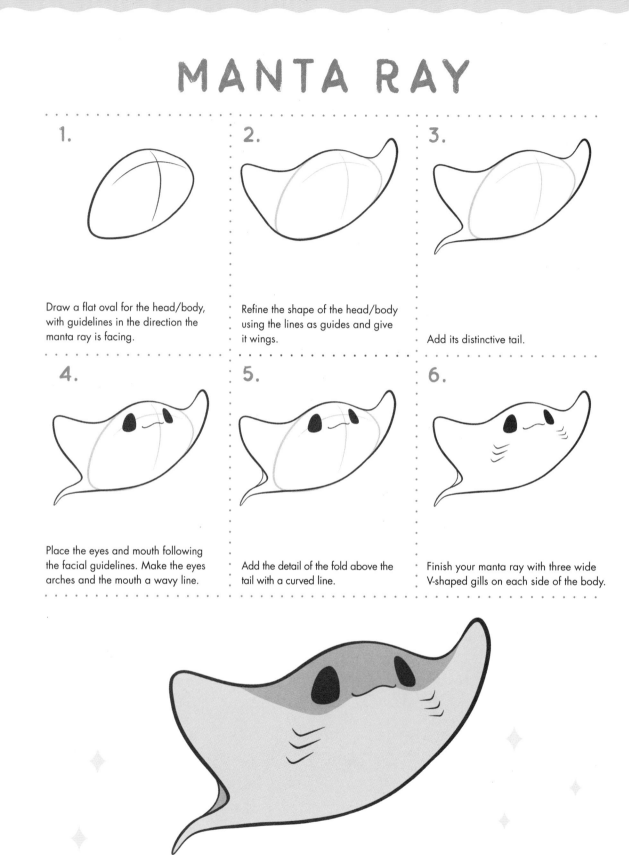

OCTOPUS

1.

Draw a large circle for the head, with guidelines in the direction the octopus is facing.

2.

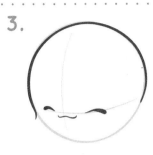

Refine the shape of the top half of the head using the lines as guides.

3.

Place the eyes and mouth following the facial guidelines. Make the eyes elongated teardrops and the mouth a wavy line.

4.

Add the siphon on the right side of the head. It should kind of look like an ear.

5.

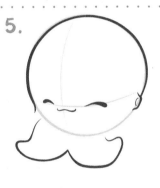

Draw the two front arms off the bottom center of the head as curved V shapes.

6.

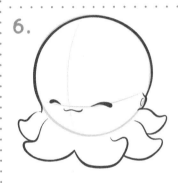

Add three more legs behind the first two. The legs should get smaller the farther back they recede.

7.

Add two legs even farther back.

8.

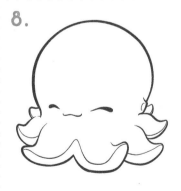

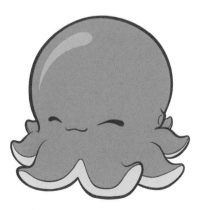

Finish your octopus by giving the legs depth with curved-line details.

SEAHORSE

1.

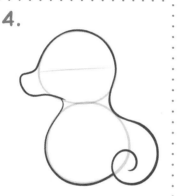

Draw a circle for the head, with a guideline in the direction the seahorse is facing.

2.

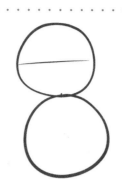

Draw a slightly larger circle below the head for the body.

3.

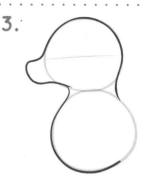

Refine the shape of the head and the front of the body. Add the distinctive snout to the left side of the head.

4.

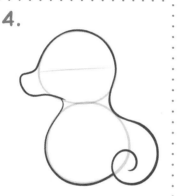

Draw a swirly tail off the back of the body.

5.

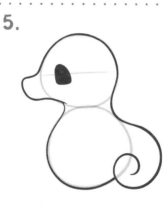

Place the eye as an arch following the facial guidelines.

6.

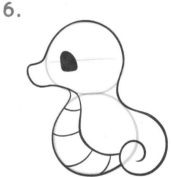

Draw a curving line to define the chest area, and then segment it with four slightly curved lines.

7.

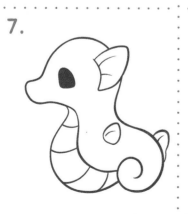

Add the three fins as upside-down V shapes in varying sizes. Draw curved lines inside them for texture.

8.

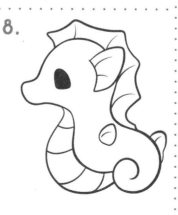

Finish your seahorse with its crowning coronet, spanning from its forehead to down its back.

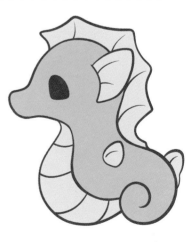

SHARK

1.

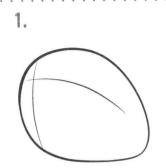

Draw a large oval that narrows on the right side for the head/body, with guidelines in the direction the shark is facing.

2.

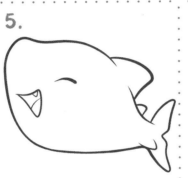

Refine the shape of the head/body using the lines as guides. Add the snout to the head.

3.

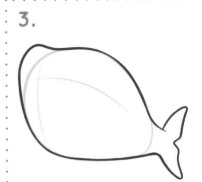

Add a tail in a semicircular shape, with a U-shaped notch in the middle to define the flukes.

4.

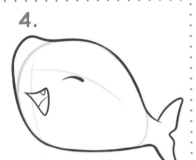

Place the eye and mouth, making the eye an elongated teardrop and the mouth a triangular shape, with a curved line for the tongue and a tiny V shape for a tooth.

5.

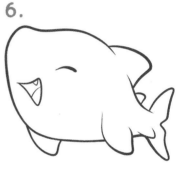

Draw the dorsal fin on top and the smaller fins near the tail as upside-down V shapes.

6.

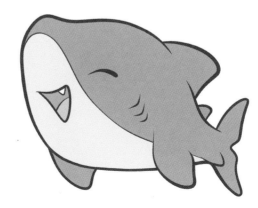

Add the pectoral fins to the sides of the body as V shapes.

7.

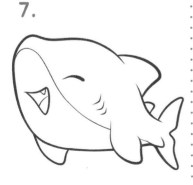

Finish your shark with three wide V shapes for the gills and a curved line for its markings.

SNAIL

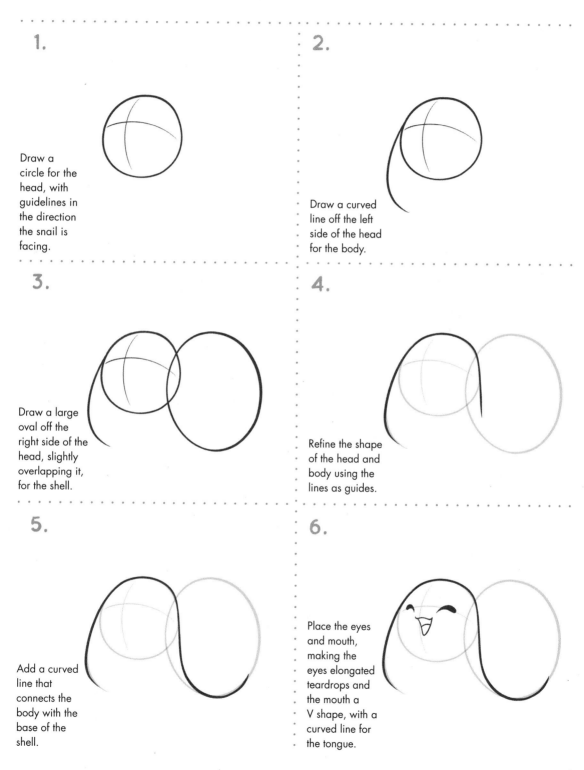

1.

Draw a circle for the head, with guidelines in the direction the snail is facing.

2.

Draw a curved line off the left side of the head for the body.

3.

Draw a large oval off the right side of the head, slightly overlapping it, for the shell.

4.

Refine the shape of the head and body using the lines as guides.

5.

Add a curved line that connects the body with the base of the shell.

6.

Place the eyes and mouth, making the eyes elongated teardrops and the mouth a V shape, with a curved line for the tongue.

There are both land and sea snails, and they can live in almost every habitat. Snails, along with their shell-less counterparts, slugs, are mollusks, like clams and oysters.

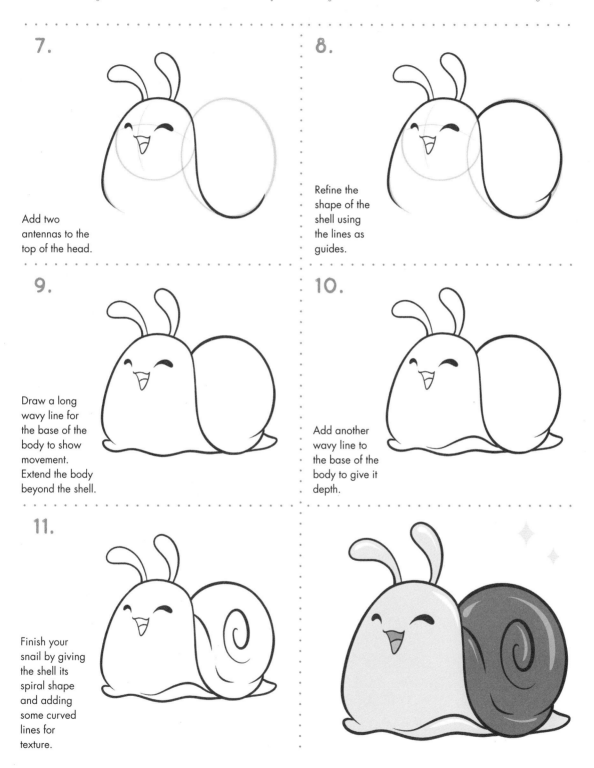

7.

Add two antennas to the top of the head.

8.

Refine the shape of the shell using the lines as guides.

9.

Draw a long wavy line for the base of the body to show movement. Extend the body beyond the shell.

10.

Add another wavy line to the base of the body to give it depth.

11.

Finish your snail by giving the shell its spiral shape and adding some curved lines for texture.

SNAKE

1.

Draw a rounded trapezoid, tilted to the right, for the head, with guidelines in the direction the snake is facing.

2.

Draw an oval, larger than the head, for the body.

3.
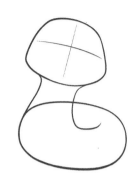

Connect the two shapes with curved lines, with the right one extending into the body.

4.
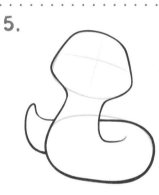

Refine the shape of the head and body using the lines as guides.

5.

Add the tail off the left side of the body, giving it a fin-like shape.

6.
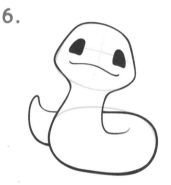

Place the eyes and mouth following the facial guidelines. Make the eyes arches and the mouth wide and wavy.

7.
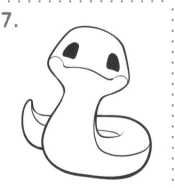

Draw curved lines on the face for markings.

8.
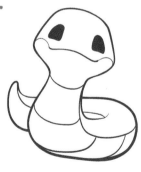

Finish your snake with four curved lines that define the segments on its underside.

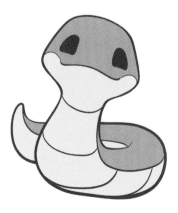

TURTLE

1.

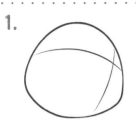

Draw a rounded trapezoid for the head, with guidelines in the direction the turtle is facing.

2.

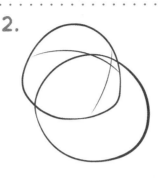

Draw an oval, overlapping half of the head, for the body/shell.

3.

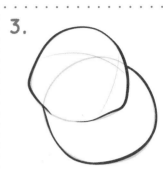

Refine the shape of the head and body/shell using the lines as guides.

4.

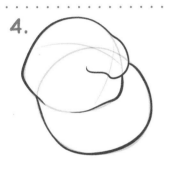

Draw the snout protruding from the head, along with a wavy line for the top of the mouth.

5.

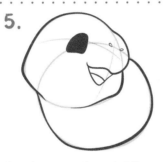

Place the eyes and nostrils following the facial guidelines. Make the eye an arch and the nostrils tiny ovals. Complete the mouth as a V shape, with a curved line for the tongue.

6.

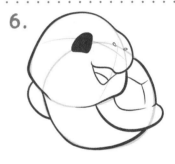

Draw the top of the shell with curved lines on both sides of the body, adding more lines to give it depth and its distinctive markings.

7.

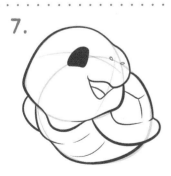

Add more curved lines to the underside of the body for the bottom of the shell.

8.

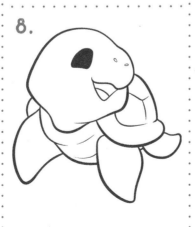

Finish your turtle with three flippers drawn as fin-like shapes.

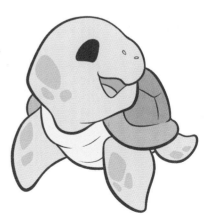

WHALE SHARK

1.

Draw a wide oval for the head/body, with guidelines in the direction the whale shark is facing.

2.

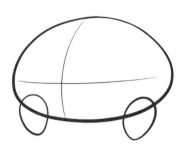

Add two smaller ovals, overlapping the bottom of the head/body, for the pectoral fins.

3.

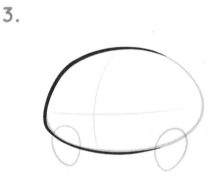

Refine the shape of the head using the lines as guides.

4.

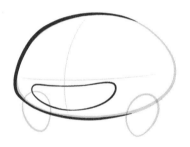

Add a wide, open mouth to the bottom half of the head following the facial guidelines.

5.

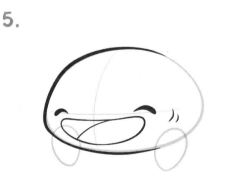

Place the eyes as elongated teardrops, add a slightly curved line to the mouth for the tongue, and draw gills on the right side of the head.

6.

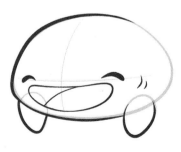

Refine the shape of the pectoral fins.

FUN FACT: *Despite their name, whale sharks are not whales but the world's largest fish. They can live between seventy and one hundred years, but only 10 percent survive into adulthood.*

7.

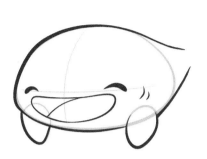

Draw converging curved lines from the body that will connect to the tail.

8.

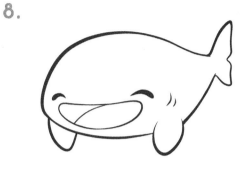

Add a tail in a semicircular shape, with a U-shaped notch in the middle to define the flukes.

9.

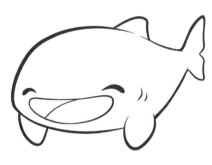

Draw a dorsal fin on top as an upside-down V shape.

10.

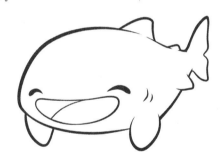

Finish your whale shark with a couple smaller fins near its tail as upside-down V shapes.

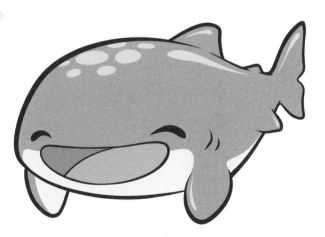